Gauguin

1848-1903

Page 4: Self-Portrait with a Palette, c.1894 oil on canvas, 92 x 73 cm Private Collection

Designed by:
Baseline Co. Ltd,
61A-63A Vo Van Tan Street
4th Floor
District 3, Ho Chi Minh City
Vietnam

ISBN 978-1-84484-957-4

- © 2010, Parkstone International
- © 2010, Confidential Concepts, worldwide, New York, USA

All rights reserved

No part of this publication may be reproduced or adapted without the permission of the copyright holder, throughout the world. Unless otherwise specified, copyrights on the works reproduced lies with the respective photographers. Despite intensive research, it has not always been possible to establish copyright ownership. Where this is the case we would appreciate notification

Printed in India

R0441130787

"In art, one idea is as good as another. If one takes the idea of trembling, for instance, all of a sudden most art starts to tremble. Michelangelo starts to tremble. El Greco starts to tremble. All the Impressionists start to tremble."

- Paul Gauguin

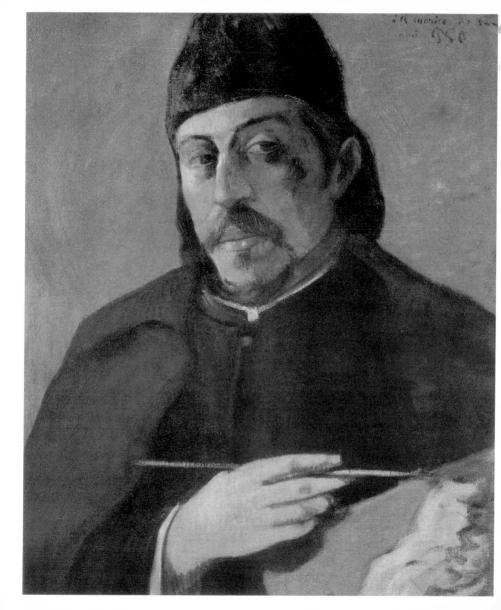

Biography

1848	Paul Gauguin born in Paris, on June 7.
1849	The family left France for Peru; his father died at sea.
1855–1861	Returned to France after a five-year stay in Lima. Lived in Orleans, his father's native town. Studied at the Petit Seminaire.
1861(?)–1865	The second secon
1865	Entered the merchant marine as a cabin-boy.
1868–1871	Served in the navy after the disbandment of the French army and navy settled in Paris.
1871–1873	Worked as a stockbrocker in the banking office of Bertin. In the house of his sister's guardian, Gustave Arosa, began to take interest in art. Became acquainted with Camille Pissarro and Emile Schuffenecker. First amateur efforts at painting.
1873–1875	Married Mette Sophie Gad, a Dane from Copenhagen. Attended the Atelier Colarossi, acquired a collection of Impressionist pictures. <i>The Seine by the Pont d'Iena</i> .
1876	Exhibited a landscape at the official Salon.
1877	Took lessons from the sculptor Jules Ernest Bouillot and produced his first sculptures.
1880	Exhibited in the 5th Impressionist exhibition (seven paintings and a marble bust).
1881	Participated in the 6th Impressionist exhibition (eight paintings and two sculptures). Spent the summer
	holidays in Pontoise with Pissarro who introduced him to Cézanne.
1882	Took part in the 7th Impressionist exhibition (twelve oils and pastels, one sculpture).
1883	Resigned from his job at Bertin's and devoted himself entirely to painting with Pissarro at Osny, where he spent his holidays studying.
1884–1885	Moved with his family first to Rouen, and then to Copenhagen, where he executed a number of paintings and wooden sculptures. Displayed interest in the Symbolist theories. Short show at the Society of the Friends of Art, Copenhagen. Left his wife and four children in the Danish capital and returned to Paris with his six-year-old son Clovis. Went to London for three weeks, later lived in Dieppe, where he made friends with Edgar Degas.
1886	Lived by turns in Pont-Aven (Brittany) and Paris; made ceramics at Ernest Chaplet's workshop. Represented in the 8th Impressionist exhibition (nineteen paintings).
188 <i>7</i>	In April, with Charles Laval, left for Panama, then moved to Martinique. Back in Paris in November, where he met Van Gogh. Organized his first one-man show at Boussod and Valadon, which included ceramics as well as Brittany and Martinique paintings. Became acquainted with Daniel de Monfreid.
1888	Lived at Pont-Aven. Produced pictures in his new synthetist and cloisonne manner. Gave 'lessons' in synthetic painting to Paul Sérusier. Painted <i>The Vision after the Sermon, Wrestling Boys, Self-Portrait</i> (with a profile of Bernard): "Les Misérables", Fruit, etc. Stayed, from October to December, with Van Gogh at Arles, where he painted Café at Arles, The Alyscamps, Old Women of Arles and other works.

Paul Gorgin

1889 Exhibited with his friends at the Café Volpini as 'Groupe Impressionniste et Synthétiste', where he showed seventeen of his paintings and a number of zincographs. Lived, alternatively, in Paris, Pont-Aven and Le Pouldu (Brittany). Painted Portrait of Meyer de Haan, The Yellow Christ, La Belle Angèle and The Schuffenecker Family. Carved the wooden relief Soyez amoureuses et vous serez heureuses (Be in love and you will be happy). Wrote two articles for the magazine Le Moderniste. Met Albert Aurier and Charles Morice. Frequented the Symbolist group at their meetings at the Café Voltaire.

On February 23, auctioned thirty of his paintings at the Hotel Drouot. On April 4, left for Tahiti.

1891–1893 The first Tahitian period. He settled first in Papeete, then at Mataeia. During these years he prod

1893

1903

The first Tahitian period. He settled first in Papeete, then at Mataeia. During these years he produced over ninety paintings (eight of them are now divided between the Hermitage, St. Petersburg, and the Pushkin Museum of Fine Arts, Moscow). Sent a number of pictures for two exhibitions in Copenhagen, one held in March 1892 (thirteen canvases), and the other in March 1893 at the Society of Free Arts (about fifty works).

Returned to France on August 30. In November arranged a show of his works at the Galerie Durand-Ruel (two sculptures and forty-four paintings, among them Landscape with Peacocks, Tahitian Pastoral Scene, Her Name is Vaïraumati, What! Are You Jealous? and At the Foot of a Mountain. Wrote Noa Noa and prepared a series of illustrations for it.

1894 Contributed to La Libre Esthétique exhibition in Brussels (January-February). Visited his family in Copenhagen. Lived alternatively in Paris and Brittany.

1895 On February 18, a sale of his works was held at the Hotel Drouot (forty-nine paintings, drawings and prints).
On July 3, he sailed to Tahiti, leaving France for good.

1895–1901 The second Tahitian period. The output of these years amounted to more than sixty paintings, numerous drawings, watercolours, woodcuts and sculptures. Rewrote the manuscript of Noa Noa and wrote a series of articles on the Catholic Church.

1897 Exhibited with the group of *La Libre Esthétique* in Brussels (*Bé Bé, Tahitians in a Room,* etc.). Learned of the death of his daughter Aline.

Physical suffering and despair reaching a sort of climax. On February 11 attempted suicide, after having painted Where Do We Come From?... as a testamentary picture. In April, having no money at all, took a post as a draughtsman and a copyist of official papers in the Bureau of Public Works at Papeete.

1899–1900 Contributed articles to the local journal Les Guêpes (The Wasps) and published the first issue of his own satirical periodical Le Sourire (The Smile). Painted two versions of Maternity, Three Tahitian Women against a Yellow Background and The Great Buddha. Birth of his son Emile, later a self-taught artist.

1901 In August, Gauguin moved to Atuona (on the island of Hivaoa, or La Dominica in the Marquesas group). Experienced a new surge of creative energy, painted And the Gold of Their Bodies, The Ford, still lifes with sunflowers and a number of landscapes.

1902 Wrote Racontars de Rapin. Painted Young Girl with a Fan, a series of still lifes with parrots and landscapes with horsemen on the beach.

Worked on his memoirs Avant et Après (Before and After). Sentenced to a fine and three-months' imprisonment for protesting at the authorities' scandalous treatment of the natives. His illness prevented him from going to Tahiti to appeal against the sentence. On May 8, a month before his fifty-fifth birthday, Gauguin died. He was buried in a small cemetery near Atuona.

n 8 May 1903, having lost a futile and fatally exhausting battle with colonial officials, threatened with a ruinous fine and an imprisonment for allegedly instigating the natives to mutiny and slandering the authorities, after a week of acute physical sufferings endured in utter isolation, an artist who had devoted himself to glorifying the pristine harmony of Oceania's tropical nature and its people died.

Garden at Vaugirard

c.1881 oil on canvas, 87 x 114 cm Ny Carlsberg Glyptotek, Copenhagen

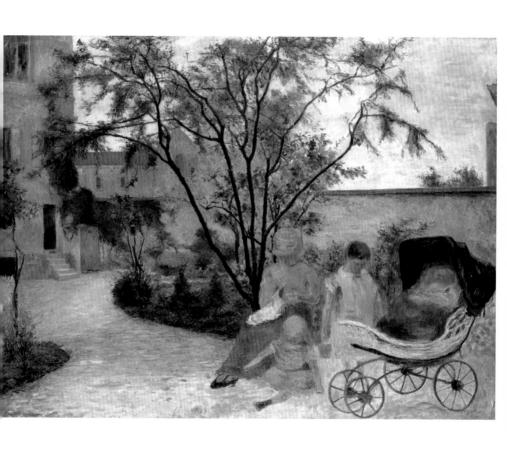

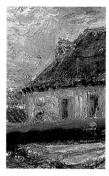

There is bitter irony in the name given by Gauguin to his house at Atuona – "Maison du Jouir" (House of Pleasure) – and in the words carved on its wood reliefs, Soyez amoureuses et vous serez heureuses (Be in love and you will be happy) and Soyez mystérieuses (Be mysterious).

Flower Vase by the Window

1881 oil on canvas, 19 x 27 cm Fine Arts Museum, Rennes

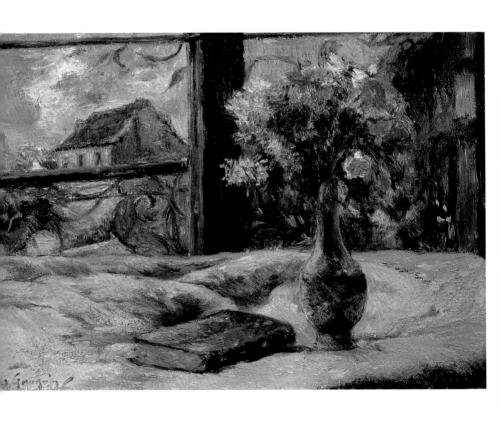

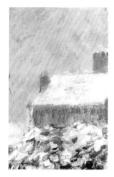

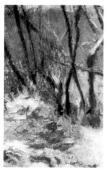

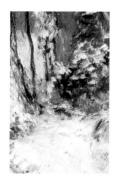

In his regular report to Paris, the bishop wrote: "The only noteworthy event here has been the sudden death of a contemptible individual named Gauguin, a reputed artist but an enemy of God and everything that is decent." It was only twenty years later that the artist's name appeared on his tombstone, and even that belated honour was due to a curious circumstance: Gauguin's grave was found by a painter belonging to the Society of American Fakirs.

Snow Effects (Snow in Rue Carcel)

1882-1883 oil on canvas, 60 x 50 cm Ny Carlsberg Glyptotek, Copenhagen

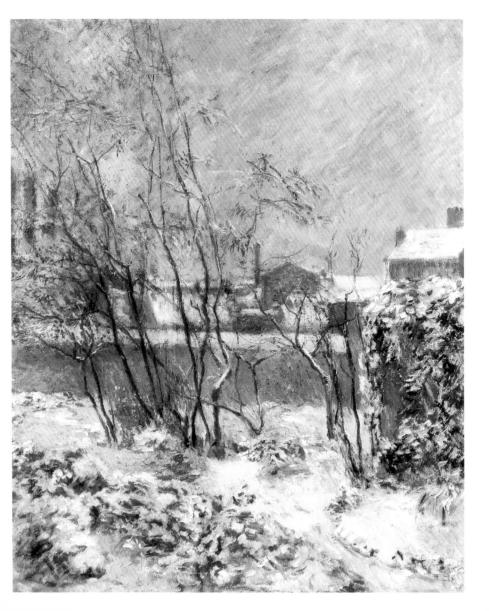

It was only due to the presence of a few travellers and colonists who knew something about art and to the ill-concealed greediness of his recent enemies who, for all their hate, did not shy away from making money on his works, that part of Gauguin's artistic legacy escaped destruction.

Sleeping Child

1884 oil on canvas, 46 x 55.5 cm private collection, Lausanne

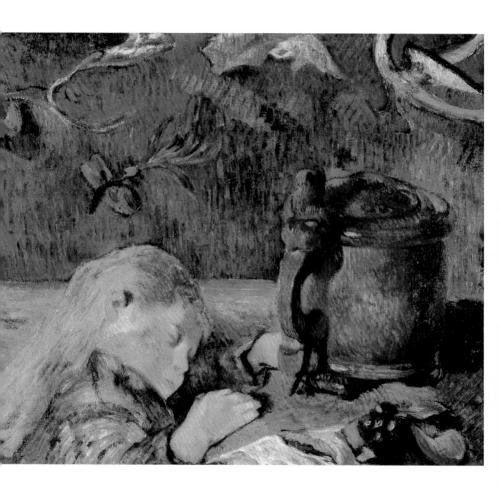

For example, the policeman of Atuona who had personally supervised the sale, destroyed with his own hands some of the artist's works, which supposedly offended his chaste morals, was not above purloining a few pictures and later upon his return to Europe, opened a kind of Gauguin museum. As the result of all this, not one of Gauguin's works remains in Tahiti.

Ice Skaters in the Frederiksberg Park

1884 oil on canvas, 65 x 54 cm Ny Carlsberg Glyptotek, Copenhagen

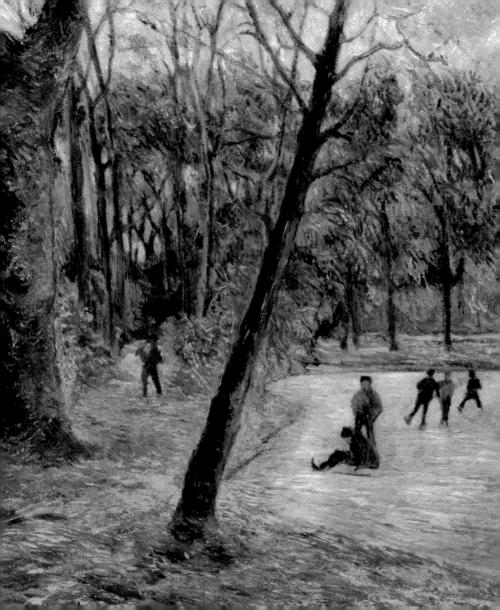

The news of Gauguin's death, which reached France with a four-month delay, evoked an unprecedented interest in his life and work. The artist's words about posthumous fame came true. He shared the fate of many artists who received recognition when they could no longer enjoy it.

Dieppe Beach

oil on canvas, 38 x 46 cm National Museum of Western Art, Tokyo

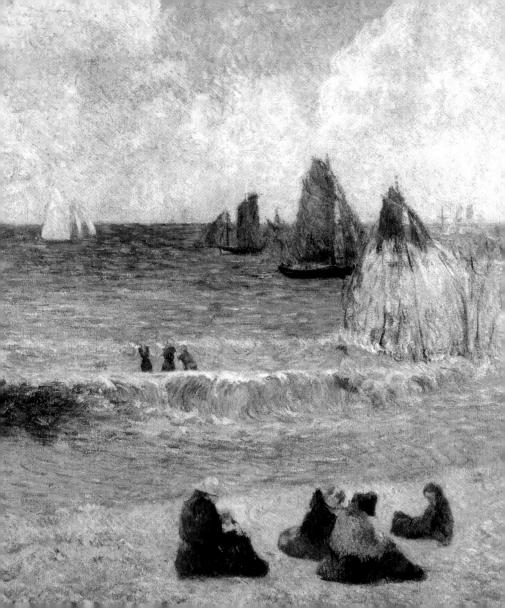

Daniel de Monfreid predicted this in a letter written to Gauguin several months before his death: "In returning you will risk damaging that process of incubation which is taking place in the public's appreciation of you. You are now that unprecedented legendary artist, who from the furthest South Seas sends his disturbing, inimitable works, the definitive works of a great man who has, as it were, disappeared

Bathers in Dieppe

1885 oil on canvas, 71.5 x 71.5 cm Ny Carlsberg Glypotek, Copenhagen

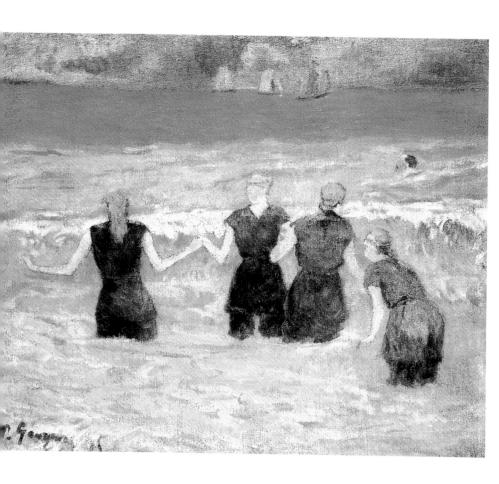

from the world. Your enemies – and like all who upset the mediocrity you have many enemies – are silent: they dare not attack you, do not even think of it. You are so far away. You should not return. You should not deprive them of the bone they hold in their teeth. You are already unassailable like all the great dead; you already belong to the history of art."

Corner of a Pond

1885 oil on canvas, 81 x 65 cm Galleria d'Arte Moderna, Milan

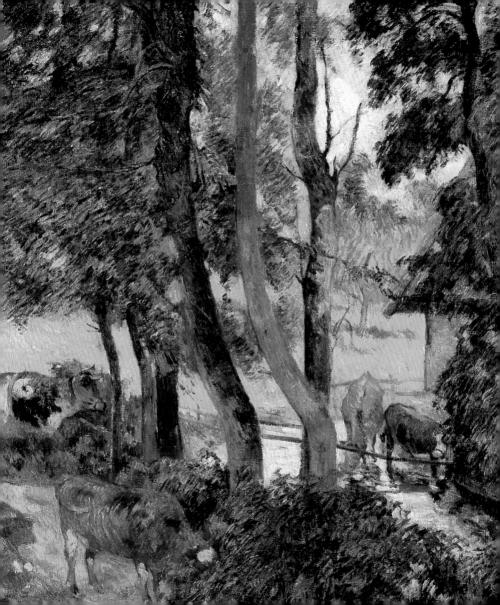

In the same year, 1903, Ambroise Vollard exhibited at his Paris gallery about a hundred paintings and drawings by Gauguin. Some had been sent to him by the artist from Oceania, others had been purchased from various art dealers and collectors. In 1906, in Paris, a Gauguin retrospective was held at the newly opened Salon d'Automne.

Self-Portrait in front of Easel

1885 oil on canvas, 65 x 54 cm private collection

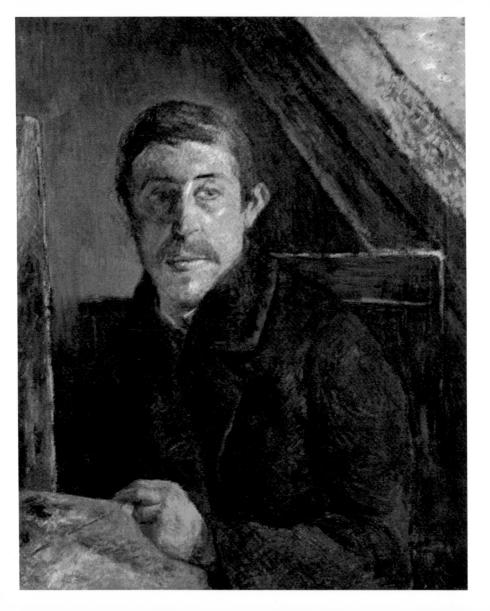

Two hundred and twenty-seven works (not counting those listed in the catalogue without numbers) were put on display – paintings, graphic art, pottery and woodcarvings. Octave Maus, the leading Belgian art critic, wrote on this occasion: "Paul Gauguin is a great colourist, a great draughtsman, a great decorator; a versatile and self-confident painter."

Self-Portrait "To My Friend Carrière"

1886 oil on canvas, 40.5 x 32.5 cm National Gallery of Art, Washington

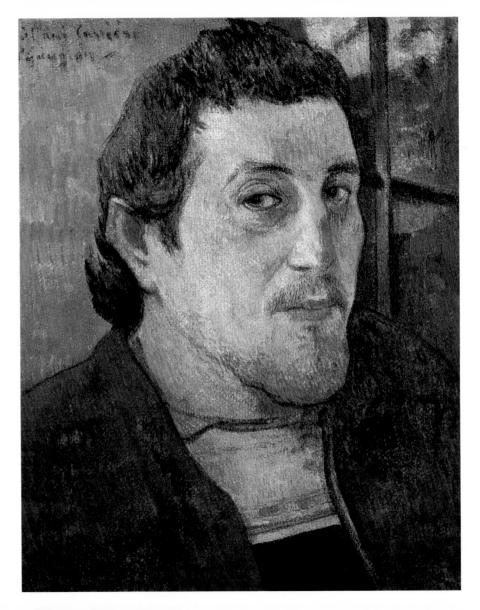

When it comes to the question of accepting or rejecting his artistic credo or of determining his place in art, the different, even mutually exclusive views expressed by different generations of researchers with different aesthetic tastes are quite justified. Some experts see Gauguin as a destroyer of realism who denounced traditions and paved the way for "free art", be it Fauvism, Expressionism, Surrealism or Abstraction.

Self-Portrait near Golgotha

1886 oil on canvas, 74 x 64 cm Museu de Arte, São Paulo

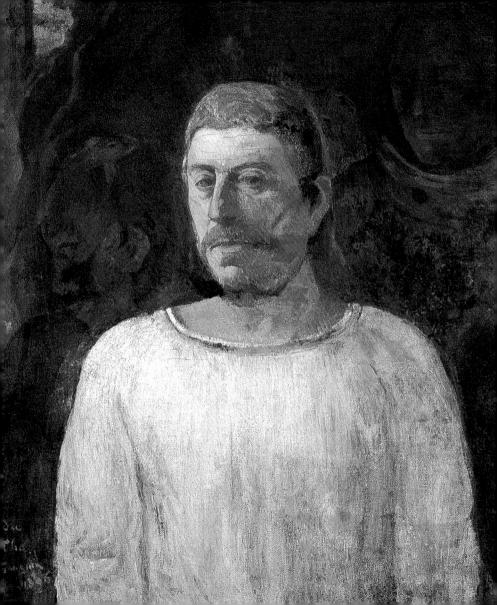

Others, on the contrary, think that Gauguin continued the European artistic tradition. Some contemporaries reacted to his departure from Europe with mistrust and suspicion, for they believed that a true artist could and must work only on his native soil and not derive inspiration from an alien culture. Pissarro, Cézanne and Renoir shared this opinion, for example. They considered Gauguin's borrowings from the stylistics of Polynesian culture to be a kind of plunder.

Young Bretons at Bath

1886 oil on canvas, 60 x 73 cm Museum of Art, Hiroshima

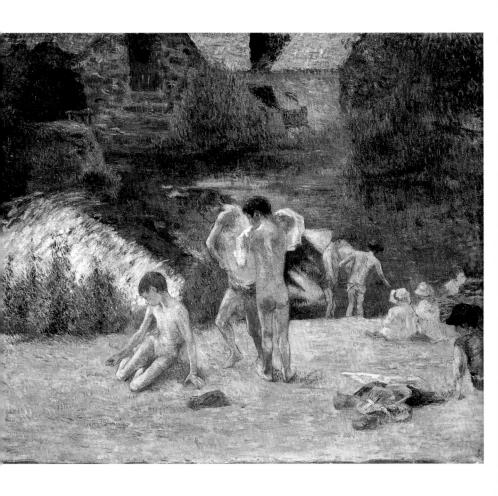

Such controversial opinions of Gauguin's art are by no means accidental. His life and work present many contradictions, though often only outward ones. His life was naturally integrated with his creative activity, while the latter in its turn embodied his ideals and views on life. But this organic unity of life and work was maintained through a never-ending dramatic struggle.

The Four Breton Girls

1886 oil on canvas, 72 x 91 cm Neue Pinakothek, Munich

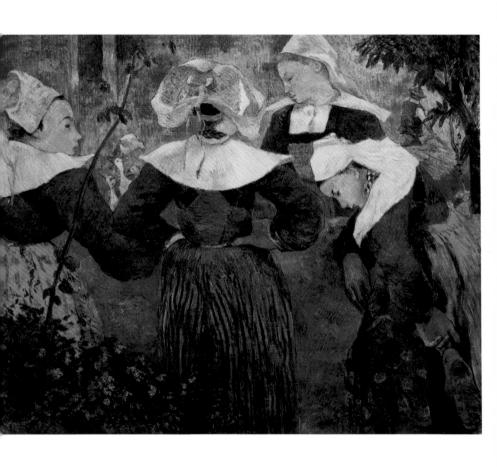

It was the struggle for the right to become an artist, the struggle for existence, the struggle against public opinion, against his family and friends who failed to understand him, and finally, it was his inner struggle for the preservation of his identity, his own creative and human self. Gauguin could hardly have become an artist who "reinvented painting" (Maurice Malingue) and who "initiated the art of modern times" (René Huyghe).

Seated Breton

1886 charcoal and pastel, 32.8 x 48 cm Art Institute, Chicago

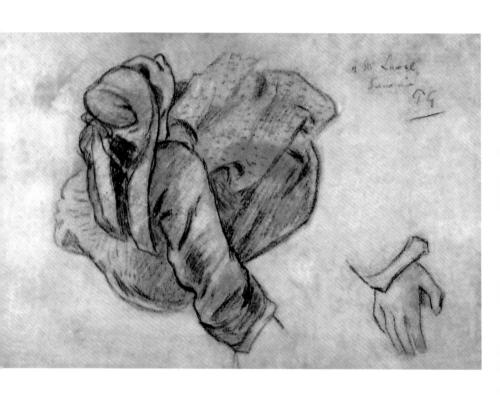

Gauguin began his career as a grown man. Nothing in his childhood or youth betrayed any hint of his future as an artist. He was born in Paris on 7 June 1848, in the midst of the revolutionary events when barricade fighting was going on in the streets of the city. This fact was to have repercussions for Gauguin's later life.

Young Breton Seated

1886 charcoal and watercolour, 30.5 x 42.2 cm Musée des Arts Africains et Océaniens, Paris

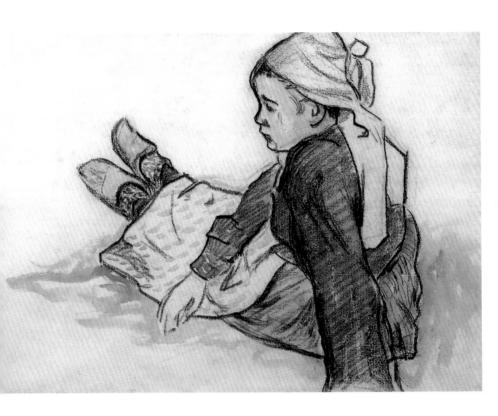

It is difficult to say whether Clovis Gauguin played an active role in the events, but it is a fact that following the failure of Marrast (who was a member of General Cavaignac's government) in the election to the National Assembly, the Gauguins left France. In the autumn of 1849, the family sailed for Peru, where they could count on the support of Mine Gauguin's distant but influential relatives.

The Vision after the Sermon (Jacob Fighting with the Angel)

1888 73 x 92 cm National Galleries of Scotland, Edinburgh

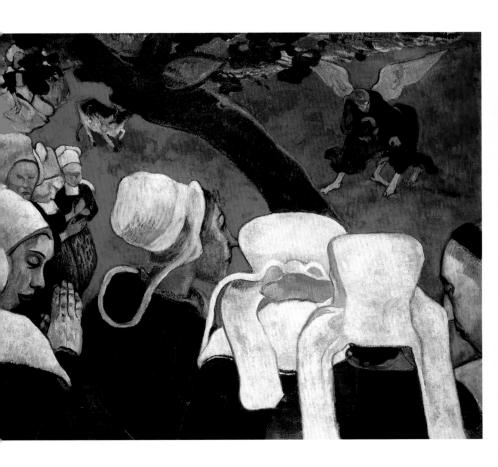

On 30 October 1849, he died at sea and his wife, with two children, had to continue the journey on her own. Childhood in Peru was forever engraved on Paul Gauguin's memory. The recollections of simple, natural relations among people with different-coloured skins, who lacked racial or social prejudice, the relations, which might have been largely idealised in the child's memory, merged with the recollections of luxuriant tropical nature with its rich colours under the dazzling sun.

Blue Trees

1888 oil on canvas, 92 x 73 cm Ordrupgaardsamlingen, Copenhagen

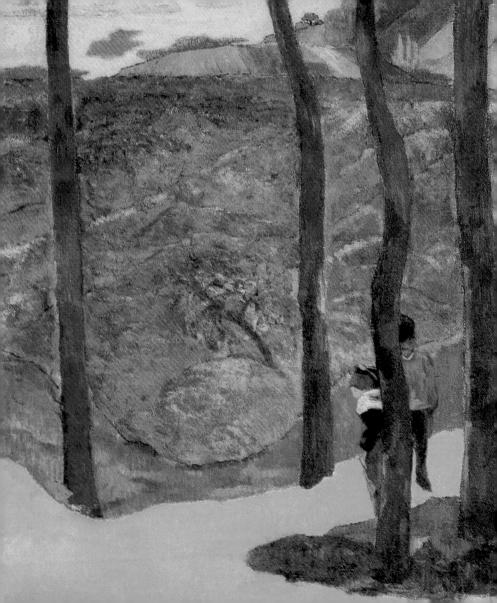

It is very likely that these early impressions determined the subsequent development of Gauguin's artistic tastes and ideals. His return to France put an end to Paul's happy and carefree life. At school in Orleans and later at a Lycée in Paris the dream of tropical countries and the sea never left Gauguin.

Bretons and Calf

1888 oil on canvas, 91 x 72 cm Ny Carlsberg Glyptotek, Copenhagen

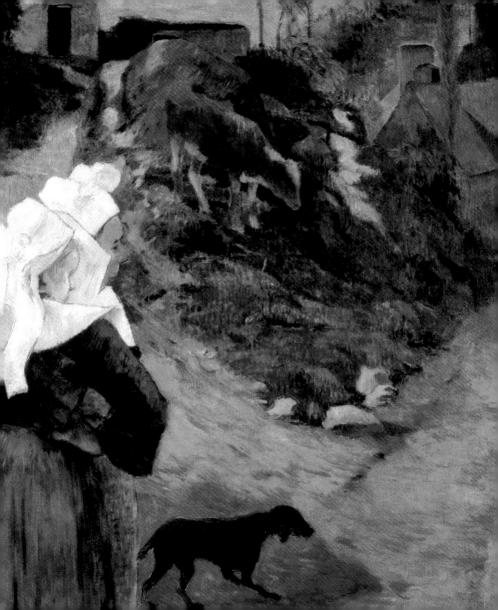

At fifteen he found employment as a cabinboy on a merchant ship and sailed to the South American coast, almost retracing the route of his first voyage overseas. But this romantic start was followed by an abrupt and unwelcome change: the Franco-Prussian war broke out, the merchant ship on which Gauguin served was requisitioned, and instead of the tropics he found himself in the north, near the Norwegian and Danish coasts.

Fighting Children

1888 oil on canvas, 93 x 73 cm private collection, Lausanne

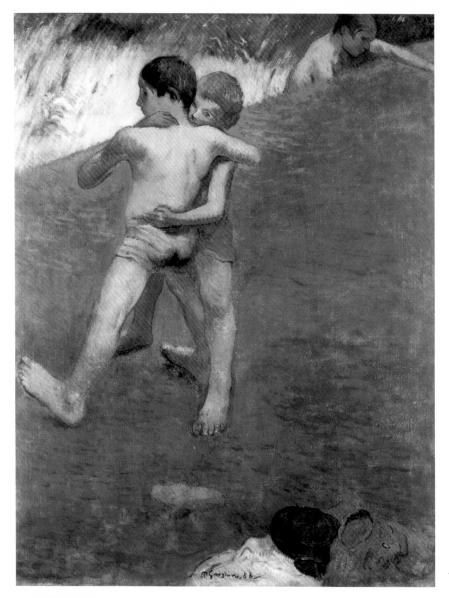

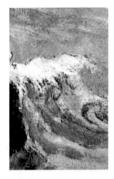

In April 1871, after the disbandment of the French forces, Gauguin returned to Paris with a third-class seaman's diploma. His mother was dead, the house at St. Cloud plundered and gutted by fire. In search of work, Gauguin turned to his sister's guardian Gustave Arosa who helped him to become a stockbroker at the Bertin bank.

The Wave

1888 oil on canvas, 49 x 58 cm private collection

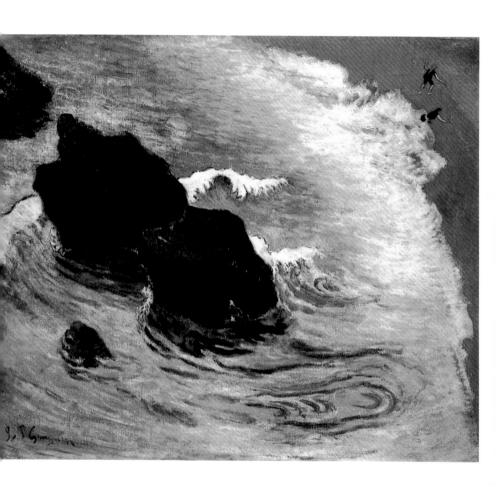

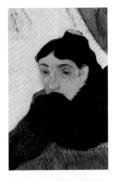

He quickly found success as a businessman, settled down to raise a family, bought a house and began to lead the orderly life of typical bourgeois. The only thing that set him apart from others in his circle was his unorthodox interest in art. It might have been stimulated by the atmosphere in Arosa's house as the owner loved painting and photography and kept a splendid collection of pictures.

Old Women in Arles (In the Arles Hospital Garden)

> 1888 oil on canvas, 73 x 92 cm Art Institute, Chicago

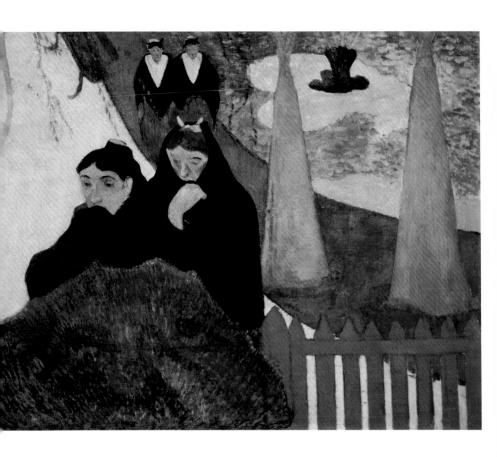

A friend of Arosa's, Nadar was a cartoonist and photographer and it was in his studio that the first exhibition of the Impressionists took place. The earliest known landscape by Gauguin is dated 1871. It was done in oils and was probably a product of the painting lessons which Gauguin attended together with Arosa's daughter Marguerite.

In the Hay (A Hot Summer Day)

1888 oil on canvas, 73 x 92 cm private collection

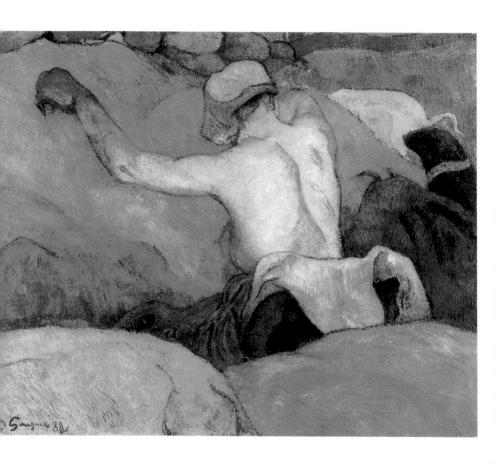

Arosa's example, as well as his own inclination, encouraged Gauguin to form a collection of pictures. Although small in size, it fairly accurately reflected his artistic taste: Manet and Monet, Pissarro and Cézanne, Renoir and Sisley – painters who had very few admirers at that time.

Café at Arles

1888 oil on canvas, 72 x 92 cm Pushkin Museum of Fine Arts, Moscow

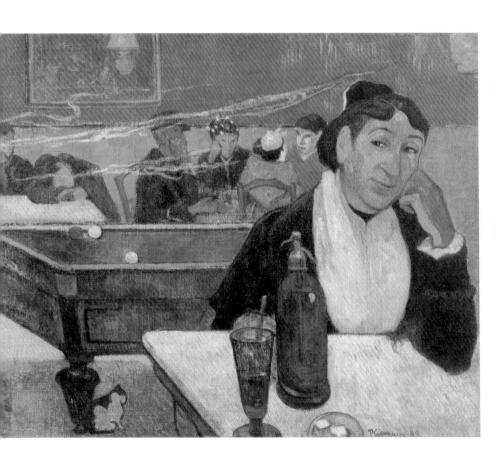

A decisive part in Gauguin's initiation into art, and especially into Impressionist painting, was played by Pissarro, who willingly advised him on both the theory and technique of painting, and actually instructed him when they worked side by side painting the same motif. At Pissarro's studio Gauguin also met Cézanne who strongly appealed to him both as a person and as an artist, and whose work greatly influenced his own.

Still Life with Fruits

1888 oil on canvas, 43 x 58 cm Pushkin Museum of Fine Arts, Moscow

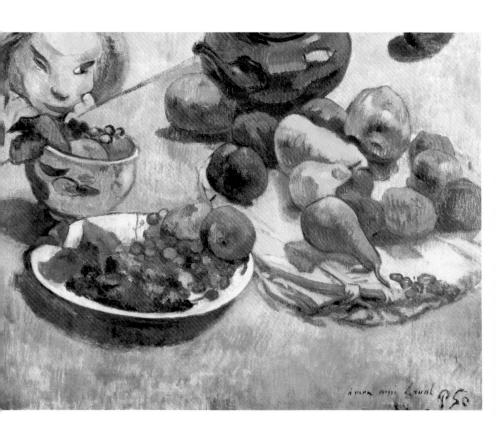

No doubt, it was with this aim in mind that Gauguin rented a house and workshop first from the ceramist and jeweller Jean-Paul Aubé, and then from the sculptor Jules Ernest Bouillot. While working at the latter's studio, Gauguin produced, first in plaster and then in marble, bust portraits of his wife and son. In 1876, Gauguin exhibited a landscape at the Salon and received a favourable press.

Human Miseries (Grape Harvest in Arles)

1888 oil on canvas, 73 x 92 cm Ordurupgaardsamlingen, Copenhagen

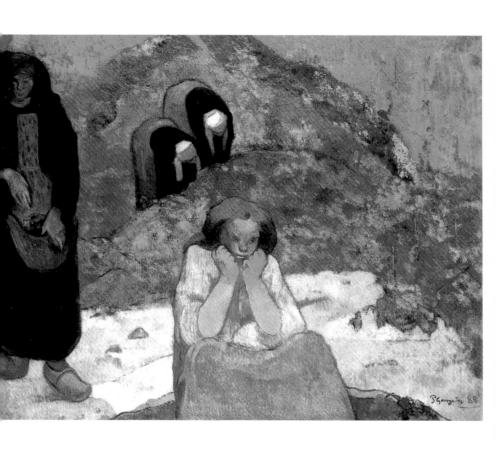

From 1879 onwards, he contributed to the Impressionist shows and actively engaged in organizational work, inviting new artists to exhibit with the group. Art was gradually ousting all other interests in Gauguin's life, and when, in 1883, he was obliged to resign from his job at Bertin's due to a financial crisis, it was not without joy – albeit not without apprehension either – that he decided to give up his banking career for good.

Self-Portrait "Les Misérables"

1888 oil on canvas, 45 x 55 cm Rijksmuseum Vincent van Gogh, Amsterdam

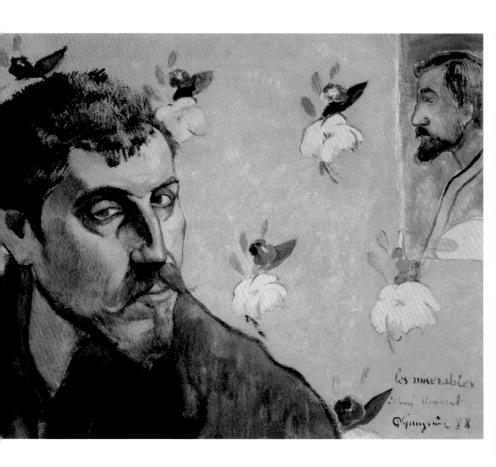

He decided to go to Copenhagen, his wife's native city. His Danish inlaws felt duty bound to make him see reason and accept a place in a company selling horse-cloths and canvas. Gauguin's attitude provoked open hostility, and as a result, in the summer of 1885, leaving his wife Mette Gad and four of their children behind, Gauguin returned to Paris with his sixyear-old son. From now on his only purpose in life was to become an artist, and not just any artist, but an outstanding one.

Breton Landscape with Pigs

1888 oil on canvas, 73 x 93 cm private collection, Los Angeles

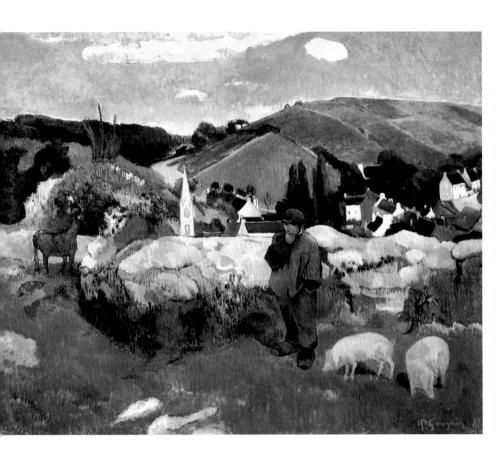

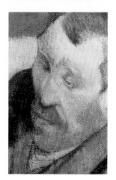

The earliest period in Gauguin's artistic career which began with his Sunday lessons in professional skills, was closely linked with Impressionism. For Gauguin, the "Impressionist is pure, not yet sullied by the putrid kiss of the Ecole des Beaux-Arts." This attitude prompted him to call the 1889 exhibition at the Café Volpini "Peinture du Groupe Impressionniste et Synthétiste", thus emphasizing the challenge to conventional salon painting.

Van Gogh Painting Sunflowers

1888 oil on canvas, 73 x 92 cm Rijksmuseum Vincent van Gogh, Amsterdam

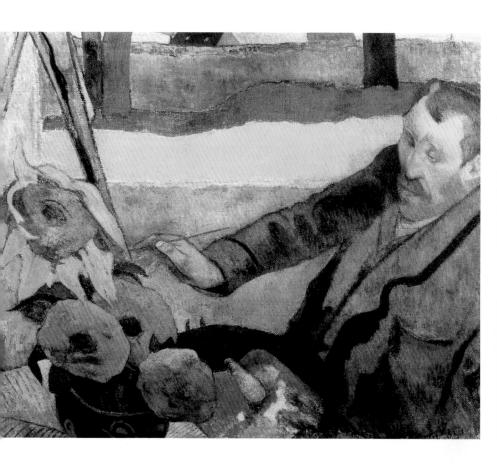

And the fact that Gauguin had found his way into art through Impressionism was of paramount importance for his further development, even though he later broke away from his teachers more decisively and uncompromisingly than any other of the Post-Impressionists.

Young Breton Bathers

1888 oil on canvas, 92 x 73 cm Kunsthalle, Hamburg

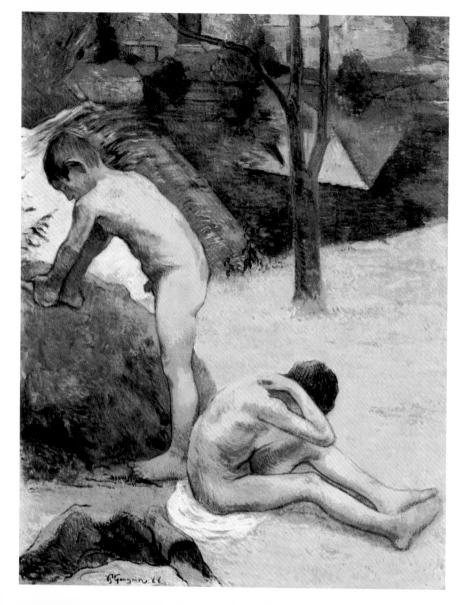

The main lesson he learnt from Impressionism was the rejection of the time-tested but antiquated traditions and the trust in the artist's own visual experience. Gauguin worked in the open air and applied his paints in small, brightly coloured dabs. He used the motifs and compositional devices of the Impressionists and discussed the issues which were important to them.

The Yellow Christ

1889 oil on canvas, 92 x 73 cm Albright-Knox Art Gallery, Buffalo

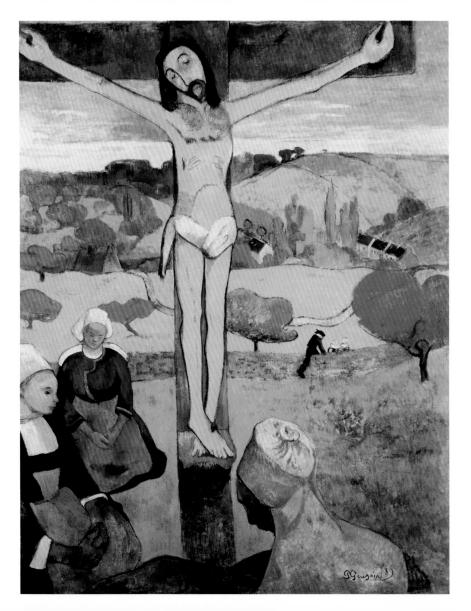

Gauguin felt the necessity to break out of the confines of Impressionism. The shimmering light which dissolved the outlines of figures and objects, and the flickering touch combined with the brightness of colour gave way to a dense brushwork and a reserved, rather dark palette, which at times brings an element of drama to the composition.

Wrack Collectors

1889 oil on canvas, 87 x 122.5 cm Folkwang Museum, Essen

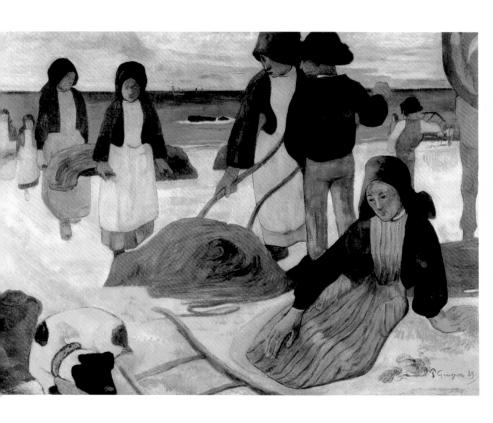

Gauguin's deviation from Impressionism first manifested itself during his stay in Rouen. It is particularly evident in his plastic works, a case in point being the carving of a small wooden jewellery box. This interest in the artist's inner feelings, in conveying an abstract idea instead of his visual impressions, was far removed from the Impressionist conception.

The Schuffenecker Family

1889 oil on canvas, 73 x 92 cm Musée d'Orsay, Paris

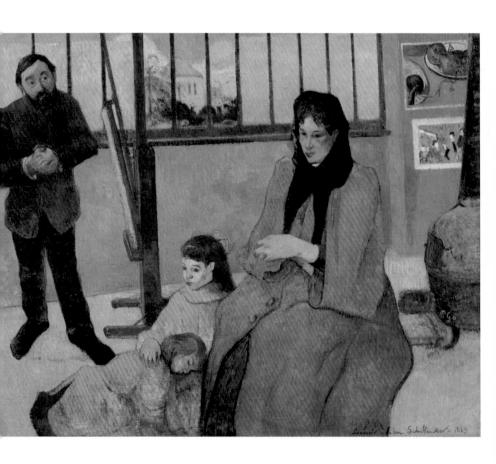

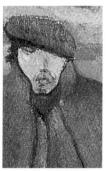

Gauguin's stay in Copenhagen, far from his recent fellow artists, stimulated him to form an independent opinion of his art, which, by his own admission, was rather "one of thought than of acquired technique."

According to Gauguin in a letter to his old friend Emile Schuffenecker (14 January 1885): "In my opinion, the great artist is the formulator of the greatest intelligence. The sentiments which occur to him are the most delicate and, consequently, the most invisible products, or translations, of the mind..."

Hello, Mr Gauguin

1889 oil on canvas, 113 x 92 cm Narodni Gallery, Prague

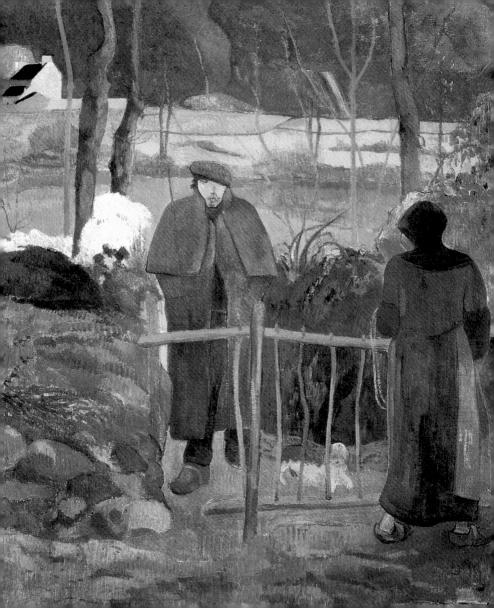

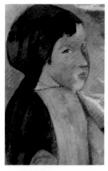

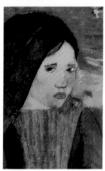

Gauguin's infatuation with Delacroix was symptomatic in many respects. In contrast to some of his contemporaries, who, like Paul Signac – the founder of Neo-Impressionism – mostly admired Delacroix as a colourist, Gauguin saw his strength in his expressive and vigorous drawing which endowed his paintings with vitality and dramatic tension.

Breton Children on the Seaside

1889

oil on canvas, 92 x 73 cm National Museum of Western Art, Tokyo

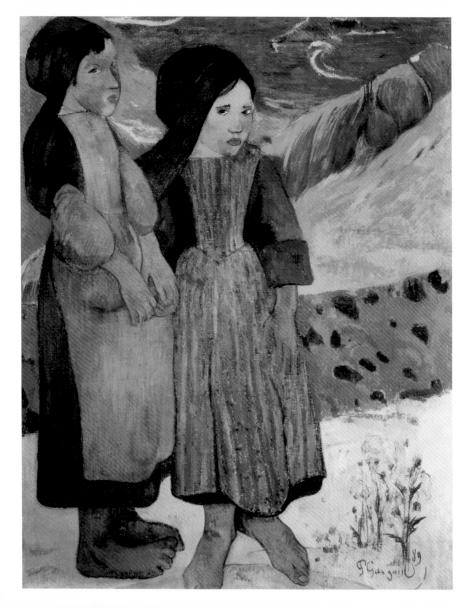

However, no matter whether Gauguin owed any of his new artistic views to Delacroix or not, it should be noted that in his letters written in early 1885 he formulated (albeit not very consistently) the fundamental principles of an aesthetic system, which was to be developed and implemented in his later work, and which he himself termed "synthetism".

Among the Waves (Ondine)

1889 oil on canvas, 92 x 72 cm Museum of Art, Cleveland

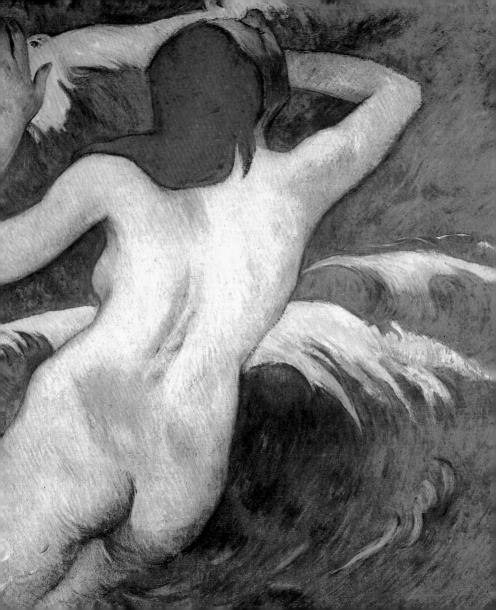

The year spent in Paris after his return from Copenhagen was one of the hardest in the artist's life. To support his son and pay the rent he had to earn money by pasting posters. However, he was able to contribute 19 paintings to the Impressionist exhibition in May 1886. He installed his son in a private boarding-school and he left for Brittany.

Christ in the Garden of Olives

1889 oil on canvas, 73 x 92 cm Norton Gallery of Art, West Palm Beach

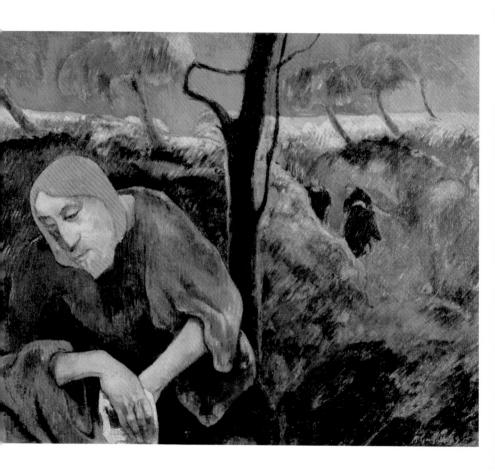

The life at Pont-Aven gave the artist relative freedom and an opportunity to think over certain issues which had long preoccupied him. Gauguin spent about six months in Pont-Aven, a small, god-forsaken place lying at the foot of two large hills. Everything in that land – its archaic way of life, its heathen-flavoured Christian monuments and its dour hardworking peasants – mirrored Gauguin's own unhappy mood.

Portrait of Meyer de Haan

1889 oil on canvas, 80 x 52 cm private collection

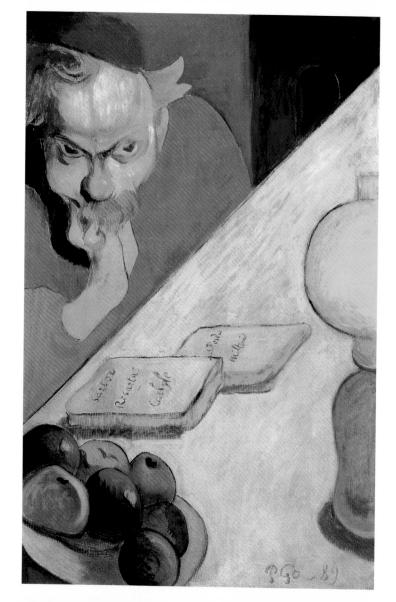

Strictly speaking, this manner was not entirely new, for it had first manifested itself in works done in Dieppe where he had spent a few weeks in the summer of 1885 after leaving Denmark. Evidence of this can be found in three canvases: The Harbour at Dieppe (City Art Gallery, Manchester), The Beach at Dieppe (Ny Carlsberg Glyptotek, Copenhagen) and Women Bathing (National Museum of Western Art, Tokyo).

Self-Portrait with the Yellow Christ

1889 oil on canvas, 92 x 73 cm Albright-Knox Art Gallery, Buffalo

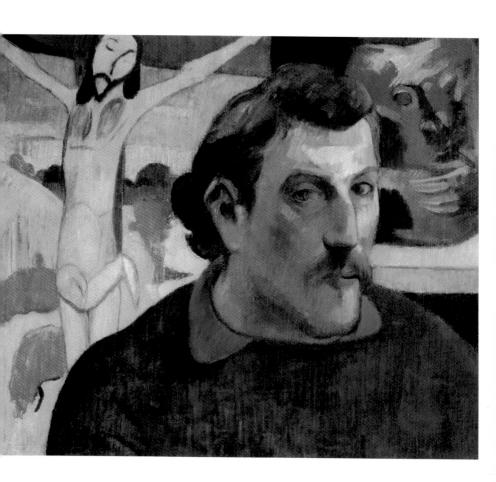

The order of their painting is unknown, but stylistically they may be assigned to three different periods. While the Harbour is a purely Impressionist work, the Beach combines Impressionist features with a novel treatment of space. The third picture bears no trace of Impressionism. Gauguin's stay in Brittany saw a further development of his new style.

Double Portrait of Children

1889-1890 oil on canvas, 46.9 x 60 cm Ny Carlsberg Glyptotek, Copenhagen

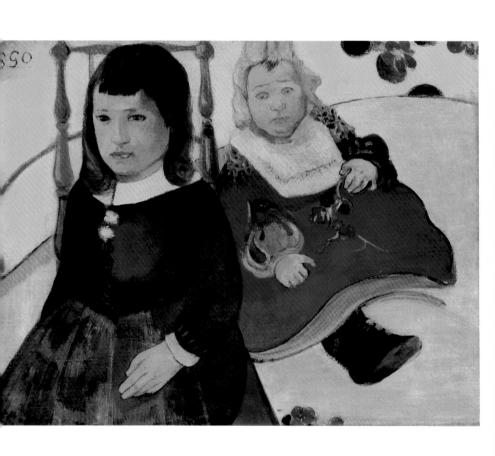

The flickering light and air of his earlier pictures gave way to flat forms. Civilization and individual freedom, particularly the freedom of a creative personality, were for him incompatible notions. Unlike other painters, including the Impressionists, he never made the city the subject of his pictures.

Look Mysterious

1890 polychrome wood, 73 x 95 cm Musée d'Orsay, Paris

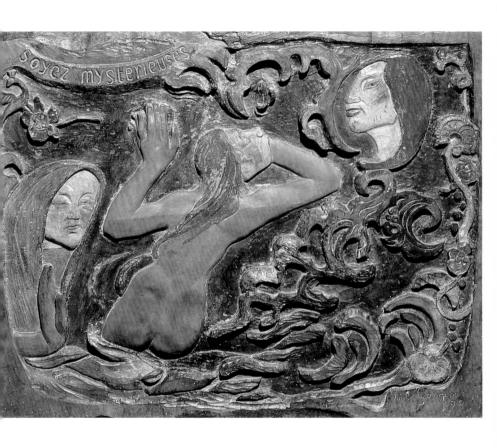

But his idea of leaving Paris had nothing to do with a rural idyll: he dreamt of distant tropical lands inhabited by free people, by savages unspoilt by the European civilization. These tropical fancies, born in the very first year of his financial troubles, were to stir his imagination from that time on with pictures of luxuriant and abundant nature, amongst which he saw himself living as a savage.

Self-Portrait

early 1890's oil on canvas, 46 x 38 cm Pushkin Museum of Fine Arts, Moscow

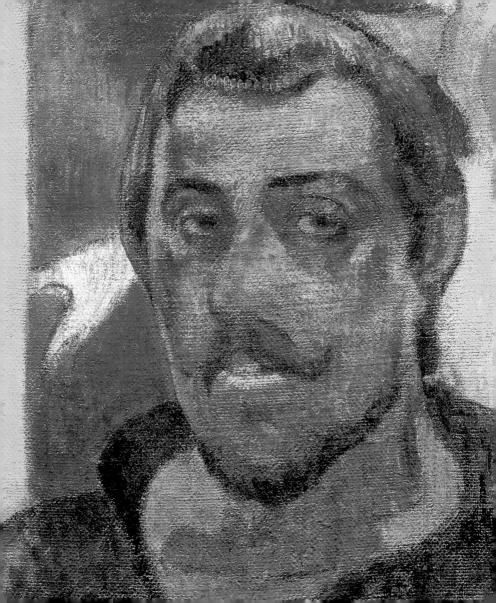

His first contact with reality, when in 1887, together with the young painter Charles Laval, he went to Panama, proved the ephemeral character of these dreams.

He had to change his brush for a spade to earn money for his passage – this time to Martinique which lured him with the same dream of a happy life, an opportunity to devote himself to painting, and of a family reunion. But in less than six months a fatal lack of money and tropical fever forced him to return to Paris.

Nirvana (Portrait of Meyer de Haan)

c.1890 oil on silk, 20 x 29 cm Wadsworth Atheneum, Hartford (USA)

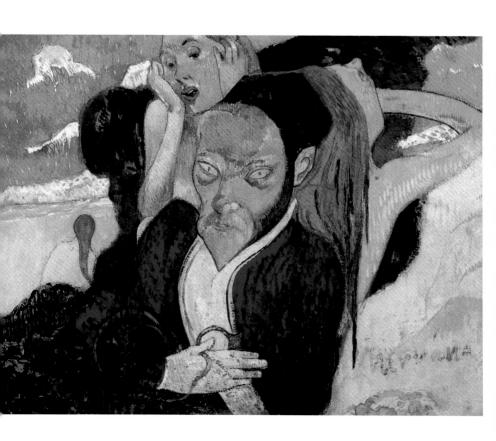

However Gauguin's stay in Martinique turned out to be extremely important, for it finally freed him from Impressionism. Nature itself showed that it could be viewed from more than just the Impressionist angle: it offered a wealth and variety that called for a different pictorial system.

Vahine no te tiare (Woman with a Flower)

1891 oil on canvas, 70 x 46 cm Ny Carlsberg Glyptotek, Copenhagen

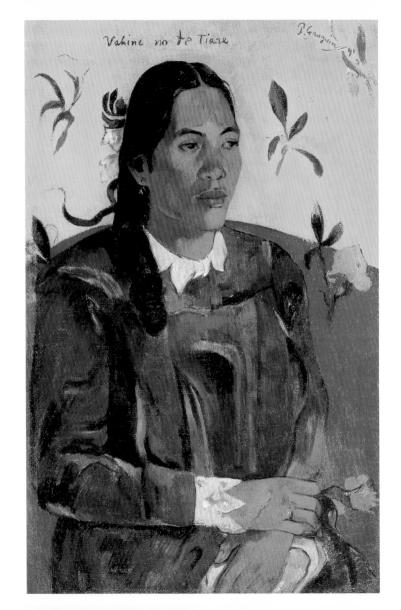

The tropical sun revealed new possibilities in the rendering of light, space, volume and colour. Hence Gauguin's new tendency to concentrate large pools of contrasting colour to stress contours and smooth, expressive lines. "I have never before made paintings so clear, so lucid", he wrote to Schuffenecker.

Man with an Axe

1891 oil on canvas, 92 x 70 cm private collection

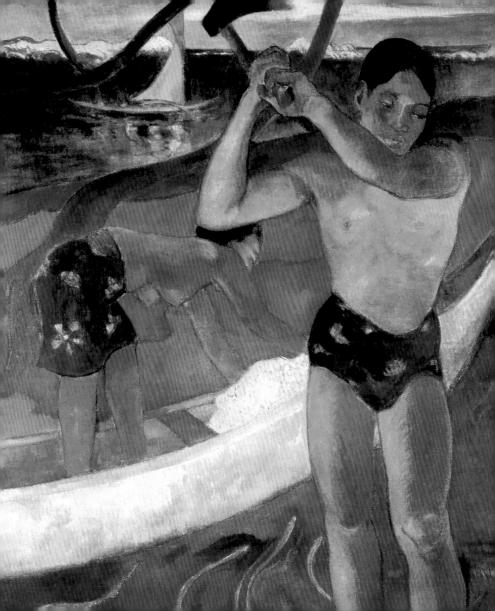

After Martinique, he remained forever faithful to the arabesque – that 'thread of Ariadne', as it was dubbed by René Huyghe, which proved so important in his future work particularly in the development of cloisonnism or synthetism.

Faaturama (Woman with a Red Dress)

1891 oil on canvas, 94.6 x 68.6 cm Nelson-Atkins Museum of Art, Kansas City

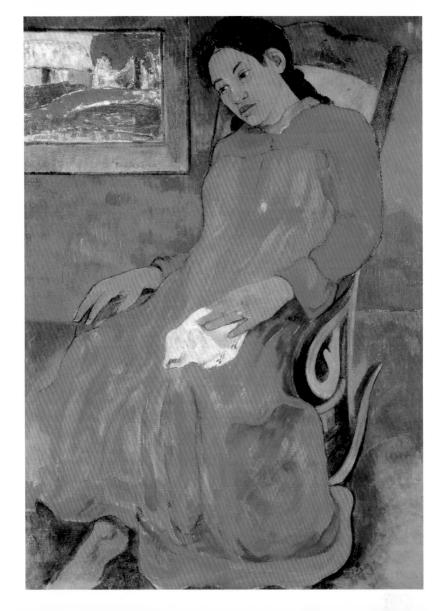

This new, real Gauguin failed to conceal his quest for a different, a non-European imagery – both in his art and in his life. To preserve moral strength for his work, he did not allow himself to get involved in any kind of emotional experience outside his creative pursuits and replied to his wife's complaints with the following words: "There are two natures in me: the Indian and the sensitive. The sensitive has disappeared, which permits the Indian to walk straight ahead firmly".

Head of a Tahitian Woman

1891 graphite, 30.6 x 24.3 cm Museum of Art, Cleveland

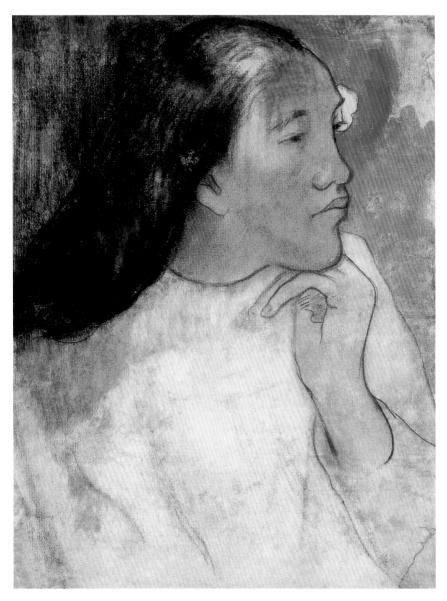

Gauguin set to work in his own way. He rejected the potter's wheel and used the primitive method of hand-moulding. And indeed, Gauguin regarded ceramics not as a craft, but as an art in its own right, a sacred creative process whose secrets he was trying to disclose through experiments with shapes and colours.

Te tiare farani (Flowers of France)

1891 oil on canvas, 72 x 92 cm Pushkin Museum of Fine Arts, Moscow

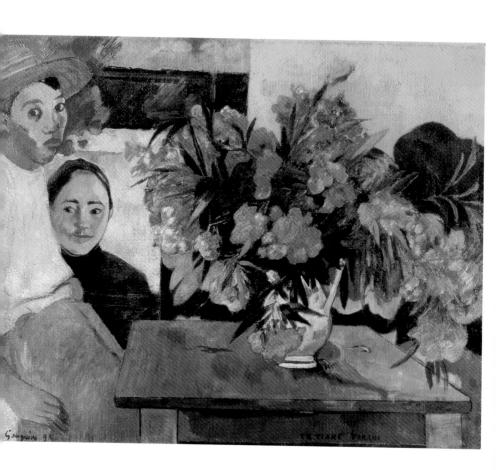

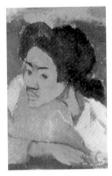

Yet, no matter how strong the impact of ceramic art was, the decisive role in Gauguin's creative evolution belonged to his own inborn inclinations which were awakened by his discovery of Martinique. A few months in Paris sufficed to reawaken Gauguin's irresistible urge to leave that city, and early in 1888 he again moved to Pont-Aven.

Les Parau Parau (Conversation)

1891 oil on canvas (relined), 71 x 92.5 cm The Hermitage, St. Petersburg

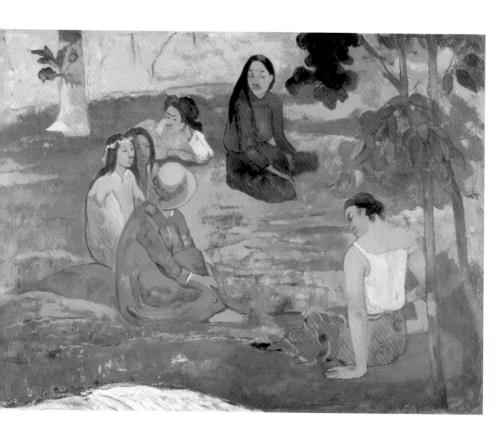

Gauguin's break with this dualism and his turning to more essential and simpler elements devoid of any narrative overtones were largely influenced by Japanese art which he admired throughout his life. The Japanese print, with its flat forms, high horizon, asymmetrical composition and a well-defined outline dividing space into chromatically uniform planes, was a source of Gauguin's theoretical essays and practical experiments.

Te raau rahi (The Big Tree)

1891 oil on canvas, 74 x 92.8 cm Museum of Art, Cleveland

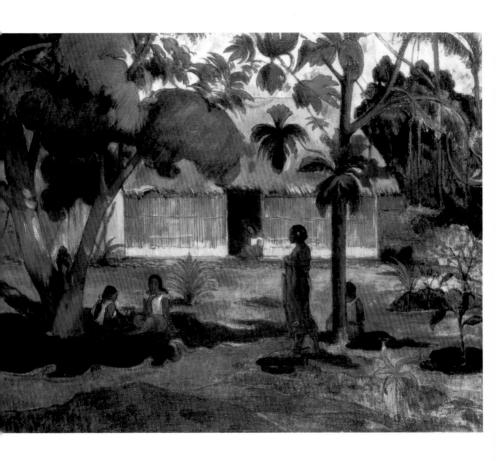

One of the first paintings, which Gauguin himself links with his new aesthetics, is Wrestling Boys (private collection, Paris). The artist was not concerned with visual verisimilitude achieved through a precise rendition of every minute detail, for he firmly believed that true art could not exist without fantasy.

Path in Papeete (A Tahitian Street)

1891 oil on canvas, 115.5 x 88.5 cm Museum of Art, Toledo (Ohio, USA)

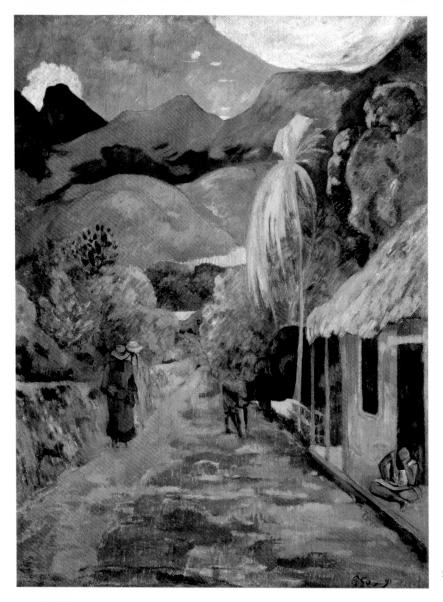

And he repeatedly expressed this view in conversations and letters. In 1888, he wrote to Schuffenecker: "A word of advice: don't paint too much direct from nature. Art is an abstraction, derive this abstraction from nature while dreaming before it, and think more of the creation that will result". As a matter of fact, these ideas began to preoccupy Gauguin three years earlier.

La Orana Maria (Ave Maria)

1891-1892 oil on canvas, 113.7 x 87.7 cm Metropolitan Museum of Art, New York

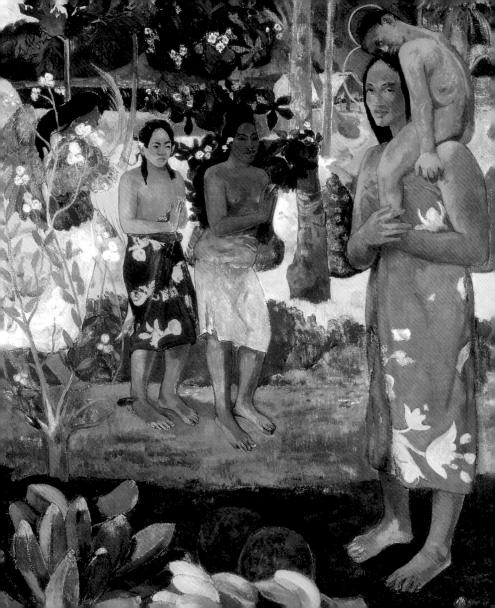

Nowadays the majority of scholars agree that the indisputable leader of the Pont-Aven school was Gauguin, although Bernard certainly made his contribution - if not in painting proper, then in the theory of the trend. At the same time, most art historians still believe that Gauguin conceived the key work of the new trend. The Vision after the Sermon, or Jacob Wrestling with the Angel (National Gallery of Scotland, Edinburgh), under the influence of the Breton Women in the Meadow by Bernard (D. Denis collection, Saint-Germain-en-Laye).

> Young Tahitian Man (Young Man with a Flower)

> > 1891 oil on canvas, 46 x 33 cm private collection

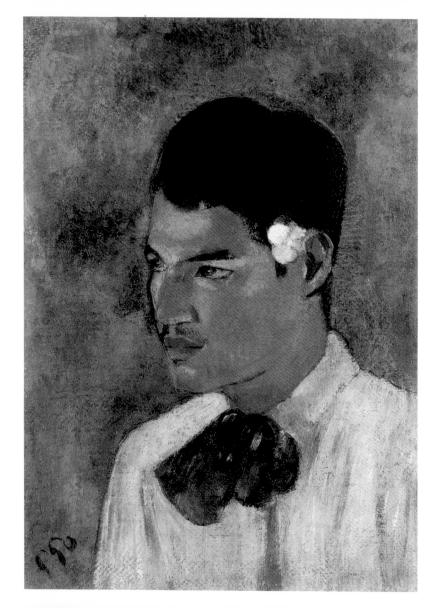

It is true that Gauguin's vision appeared after *Breton Women*, but this does not necessarily imply (as was convincingly shown by Mark Roskill) that he was influenced by Bernard's picture, for the general tendency of Gauguin's creative evolution and some of his previous works indicated a new artistic outlook and a realization of this in his painting.

The Rest

1891-1892 or 1894 oil on canvas, 87 x 116 cm private collection, New York

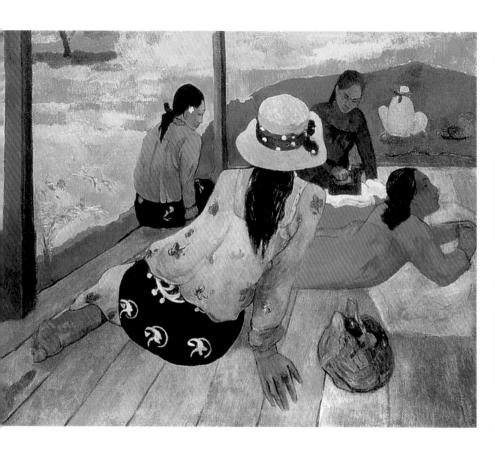

Thus, having long sensed the conflict between the Impressionist outlook and his own, he gradually arrived at a strikingly precise formula: "For them there is no such thing as a landscape that has been dreamed, created from nothing. They focused their efforts around the eye, not on the mysterious centre of thought".

Evil's Word (Eve)

c.1892 pastel on paper, 77 x 35.5 cm Kunstmuseum, Basle

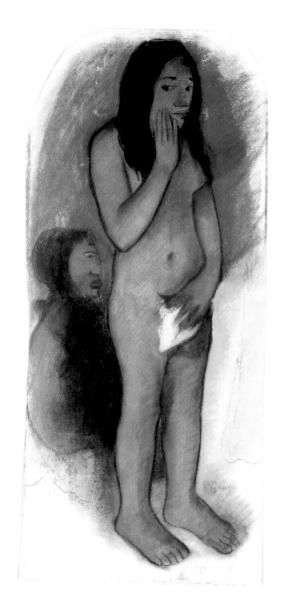

He was not satisfied with painting from life and recording visual experiences, yet life and nature were something he could not do without, for they inspired his dreams and fantasies, nourishing his imagination. He passed on the phenomena of life through the prism of his artistic vision and they re-emerged in a concentrated, generalized form. Hence the

Parau Na Te Varua Ino (Evil's Words)

1892 oil on canvas, 91.7 x 68.5 cm National Gallery of Art, Washington

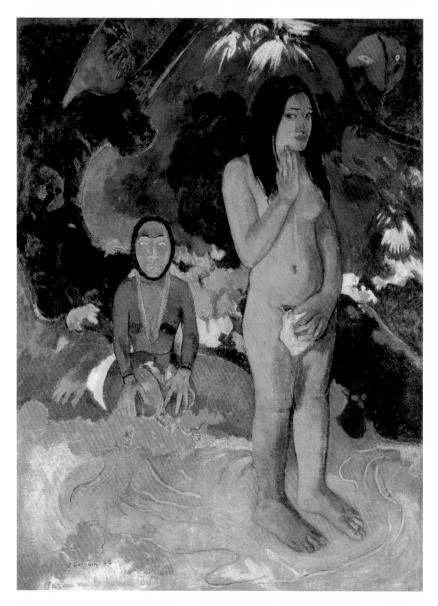

replacement of concrete individual images with synthetic ones, bearing the eternal truth and recreating the mysterious past, the childhood of mankind – that is, all that was to become his major theme, particularly after his escape from Europe. This view on the essence of painting presupposed the artist's right to transform life with the help of emphatic linear treatment and expressive, strongly suggestive colouring so as to capture its intrinsic harmony and rhythm.

Arearea (Happiness)

1892 oil on canvas, 75 x 94 cm Musée d'Orsay, Paris

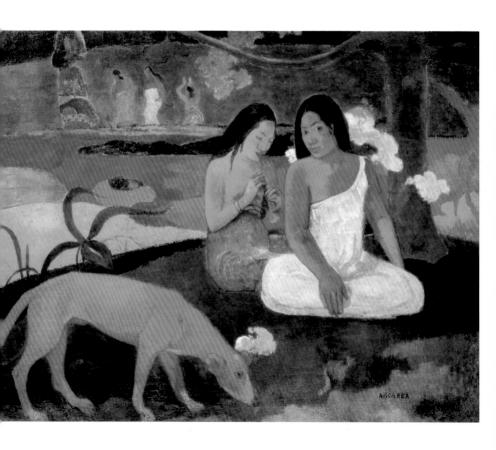

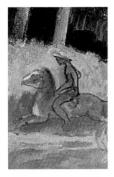

The Breton period was interrupted by a two-month visit to Arles, where he was invited by Van Gogh who looked forward to founding a kind of 'Workshop of the South' (L'Atelier du Midi) modelled on a medieval guild, in which likeminded artists could work together along new lines. The idea was doomed to failure, for Gauguin was the only painter who joined Van Gogh, and mainly because he hoped Vincent's brother Theo might help him escape from his poverty.

Fatata te moua (At the Foot of the Mountain) or The Big Tree

1892 oil on canvas, 67 x 91 cm The Hermitage, St. Petersburg

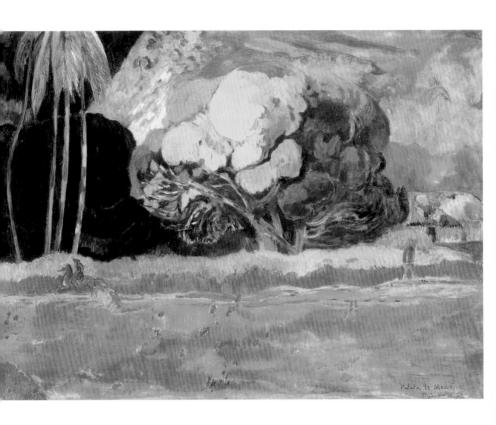

However dramatic their life together turned out to be, this period of intimate artistic communion had a profound significance for the work of both Gauguin and Van Gogh. Working side by side, each eager to prove he was right, they tried to re-examine a number of important questions.

Vaïraumati tei oa (Her Name is Vaïraumati)

1892 oil on canvas, 91 x 68 cm Pushkin Museum of Fine Arts, Moscow

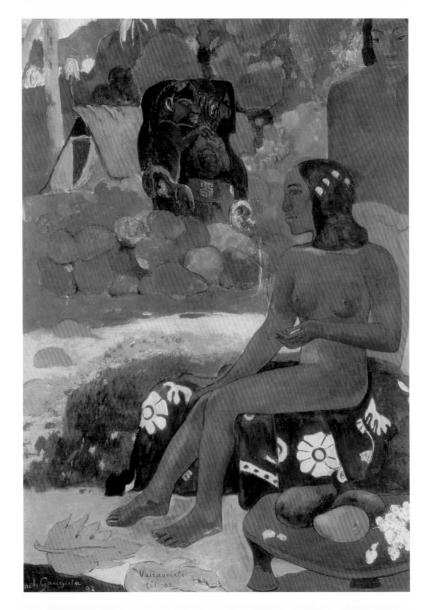

Perhaps it was in Arles that Gauguin finally saw what Japanese engraving could offer to his theory of synthesis. In any case, his attitude towards the treatment of light and shade, one of the basic means of reproducing reality in traditional European painting, came from the southern city.

Ta matete (The Market)

1892 tempera on canvas, 73 x 92 cm Kunstmuseum, Basle

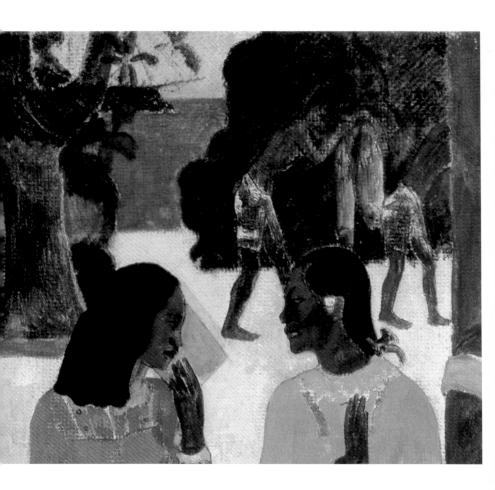

During the two months when Van Gogh and Gauguin were in daily contact, the impact of their work was felt – both directly and indirectly – in the mutual borrowing of certain stylistic features and, even more so, in mutual differences. At times Gauguin and Van Gogh turned to the same subject, at which point the difference in their interpretation of visual experiences became even more apparent.

Aha oe feii? (What? Are You Jealous?)

oil on canvas, 66 x 89 cm
Pushkin Museum of Fine Arts, Moscow

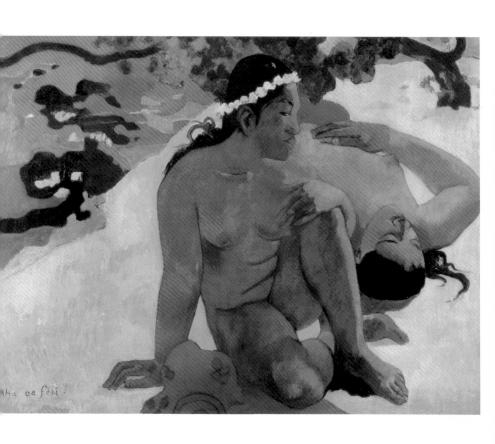

Such are Gauguin's Old Women of Arles (Art Institute of Chicago) and Van Gogh's Ladies of Arles (Reminiscence of the Garden at Etten, Hermitage, St. Petersburg). Gauguin knew what he meant when he wrote that the women of Arles, "with their shawls, falling in folds, are like the primitives, like Greek friezes".

Matamoe (Landscape with Peacocks)

1892 oil on canvas, 115 x 86 cm Pushkin Museum of Fine Arts, Moscow

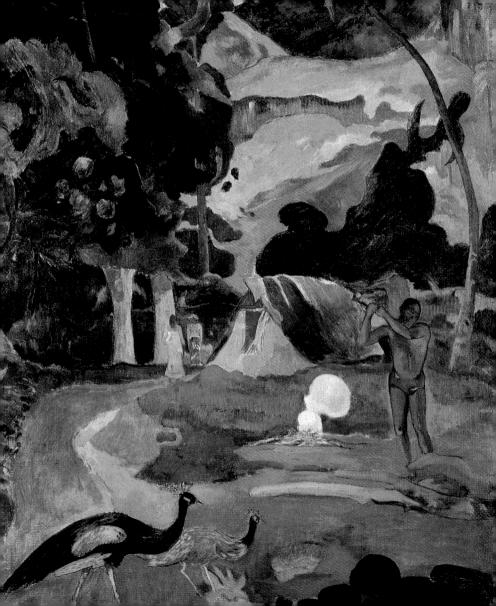

He treats the figures and the landscape in a very economic manner, simplifying and generalizing forms and transforming volumes into flat silhouettes defined by near geometric contours and local colour. Van Gogh's picture, on the other hand, has nothing of the decorativeness of Gauguin's composition, with its mournful procession of women passing through a hospital garden and its undisturbed equilibrium of forms.

E haera oe i hia? (Where Are You Going?)

1892 oil on canvas, 96 x 69 cm Staatsgalerie, Stuttgart

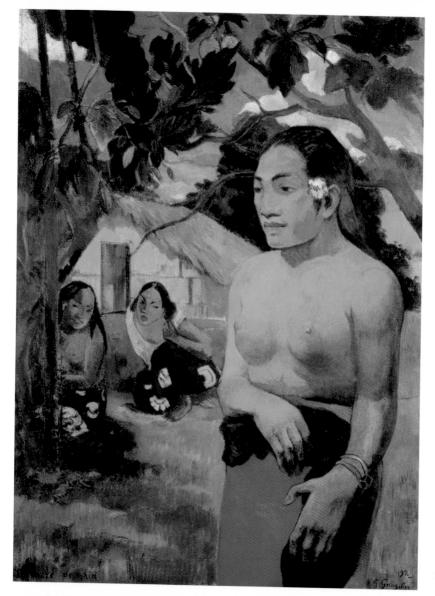

Gauguin's sojourn at Arles was cut off rather abruptly and unexpectedly. Van Gogh's extreme excitability and recurrent depressions turned the life of the two artists into a series of violent arguments and subsequent reconciliations. Van Gogh's attempt at suicide put an end to Gauguin's stay at his house.

Nafea faa ipoipo? (When Will You Marry?)

1892 oil on canvas, 105 x 77.5 cm Rudolf Staechelin Foundation, Basle

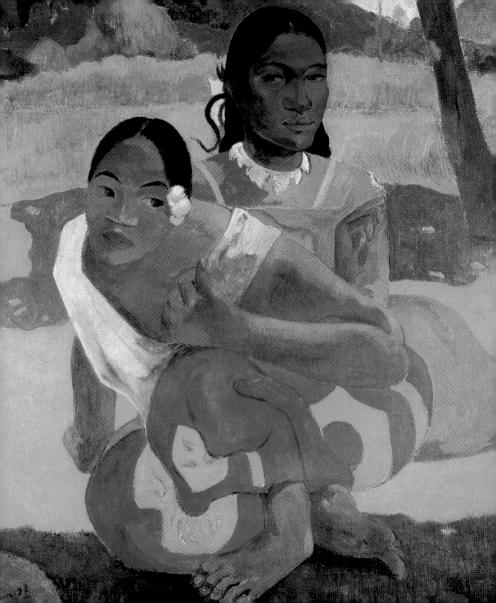

As soon as Theo had arrived at Arles and arranged for his brother to go into an asylum at his own request, Gauguin left for Paris. Finding himself back in the capital without funds, while waiting for the results of the Brussels exhibition (held in February-March 1889) Gauguin organized an exhibition of like-minded artists, which took place in the Café Volpini in March and April that year.

Manao Tupapau (The Soul of the Dead Ones is Awake)

> oil on canvas, 73 x 92 cm Albright-Knox Art Gallery, Buffalo

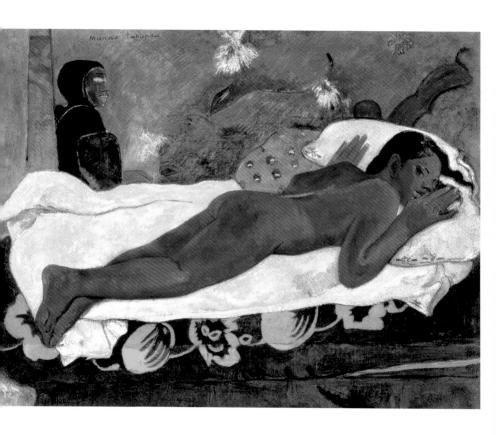

On his return to Paris, however, Gauguin felt a new strength welling up inside him. While still in Arles, he had written that he was as yet involved in a minor artistic skirmish, but was preparing for a great battle. "I want to go onto the attack only when I have all the necessary material in my hands".

Fatata te miti (On the Seashore)

1892 oil on canvas, 68 x 92 cm National Gallery of Art, Washington

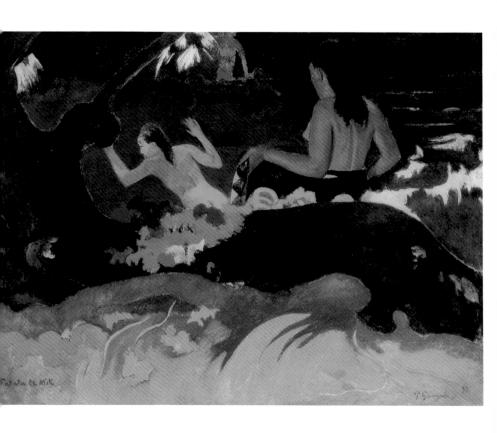

By 1889 all the preconditions for the "great battle" had been fulfilled. Having spent two months in Paris, Gauguin again left for Brittany, first to Pont-Aven and then to Le Pouldu, a small fishing village, where he rented a house together with his new friend and pupil Meyer de Haan.

Otahi (Alone)

1893 oil on canvas, 50 x 73 cm private collection

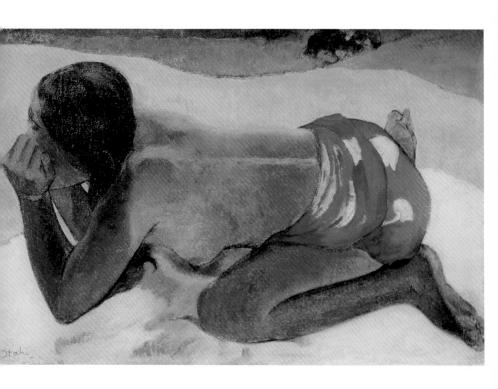

This time he began to see Brittany – its landscapes and colours – in a new light. Dull and uninspiring in winter, it was magically transformed by the summer and autumn sun. Yellow became Gauguin's favourite colour, dominating the palette of many of his Breton pictures, joyous and radiant as never before.

Aïta tamari vahine Judith te parari (Annah the Javanese)

1893-1894 oil on canvas, 116 x 81 cm private collection

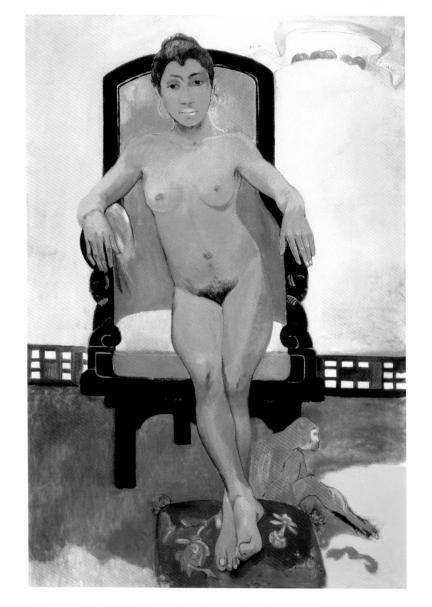

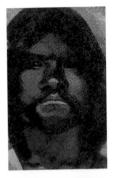

Such are his Haymaking in Brittany (Courtauld Institute Galleries, London), The Yellow Haystacks, or The Golden Harvest (Musée d'Orsay, Paris), The Brittany Landscape (Nationalmuseum, Stockholm), two landscapes (Nasjonalgalleriet, Oslo), The Yellow Christ (Albright-Knox Art Gallery, Buffalo) and many other compositions.

Hina tefatou (The Moon and the Earth)

1893 oil on canvas, 112 x 92 cm Museum of Modern Art, New York

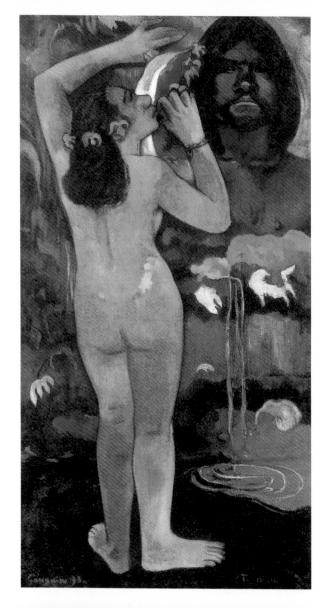

Yellow was the dominant colour, others – red, dark blue and purple, applied in broad sweeping strokes – were subservient to it. Used in various combinations, it determined the emotional key of the picture.

The style of these paintings already bore some features, which were to develop later, during Gauguin's Polynesian period.

Tahitian Pastoral Scene

1893

oil on canvas, 86 x 113 cm The Hermitage, St. Petersburg

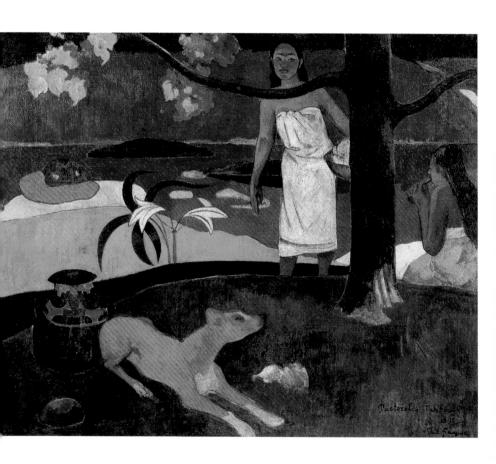

And it was in this same light that Gauguin saw Breton fishermen, peasants and their children; to him they were also left aside by society, which hurried on with its cultural development. He painted them in a manner rejecting the deceptively flattering veil of the plein-air technique.

Merabi metua no Tehama (Teha'amana Has Many Parents)

> 1893 oil on canvas, 76 x 52 cm Art Institute, Chicago

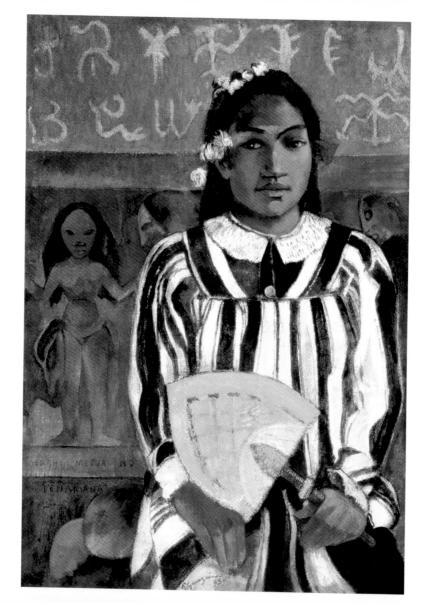

But the savage primitiveness of Brittany was gradually losing its appeal for Gauguin. His poverty and the humiliating dependence upon his friends' support made life unbearable. During his visits to Paris from Brittany, Gauguin was a frequent guest at the literary clubs of the Symbolists.

Eu haere ia oe (Where Are You Going?) or Woman Holding a Fruit

1893 oil on canvas (relined), 92 x 73 cm The Hermitage, St. Petersburg

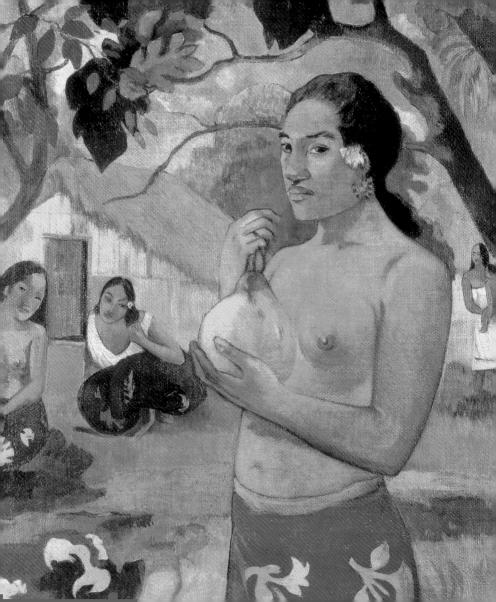

His meetings with the leading Symbolist poets, critics and theorists – Mallarmé, Mirbeau, Moréas, Aurier and Morice – and his participation in their literary discussions were a stimulating experience. At the same time, Gauguin was put on his guard, as it were, by the Symbolist literary aesthetics, and by the refinement of Parisian poets whose acute resentment of naturalism had led them away from reality and into an artificial, imaginary world.

Self-Portrait with a Hat

winter 1893-1894 oil on canvas, 46 x 38 cm Musée d'Orsay, Paris

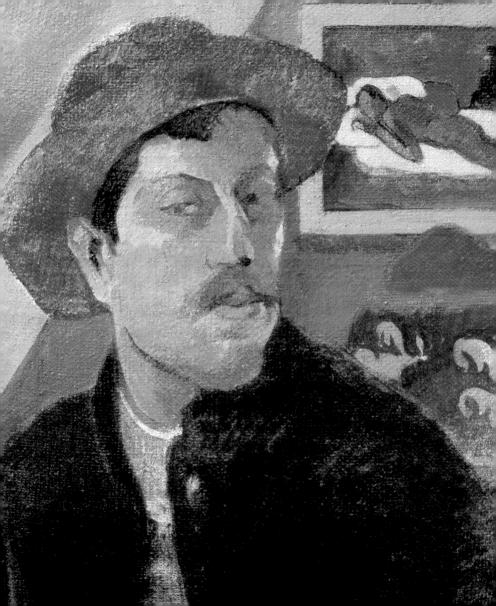

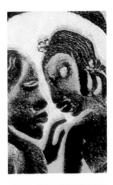

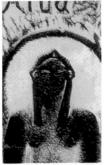

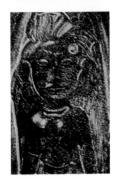

The emotional and spiritual depth of Gauguin's works, combined with their decorativeness and monumentality of forms, induced Albert Aurier, a young poet and an ardent exponent of Symbolism, to hail Gauguin as the head of the Symbolist movement in art. The dream of a land caressed by a generous sun, of a land where the primitive is a natural phenomenon and not something imposed through historical and literary reminiscences, became almost an obsession.

Te Alua (The God)

1893-1894 woodcut for Noa Noa, 20.3 x 35.2 cm Art Institute, Chicago

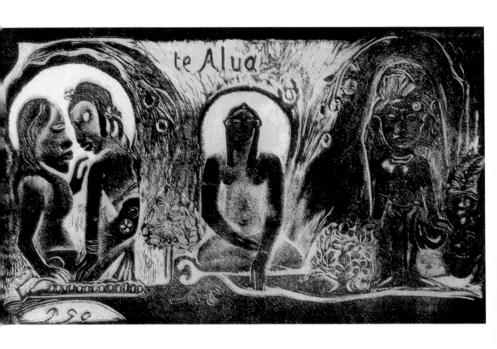

During the World Fair of 1889 in Paris, Gauguin was a constant visitor to the African, Javanese and Polynesian pavilions.

Indochina, Japan, Madagascar or Tahiti

– in short, everything that was not Europe and
that was not touched by bourgeois relationships – all equally attracted Gauguin. "All
the Orient – the great thought written with the
golden letters in all their art; it's all worth

Maruru (Satisfied)

1893-1894 woodcut for Noa Noa, 20.5 x 35.5 cm Art Institute, Chicago

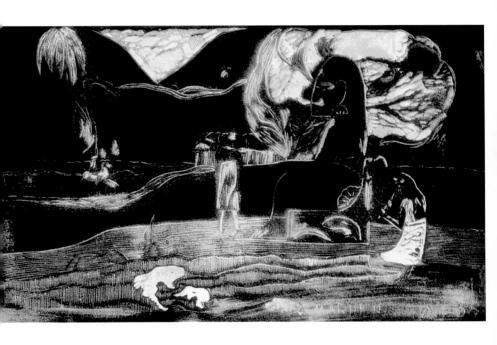

studying. And it seems to me that I'll reimmerse myself there," he wrote when the decision to leave France had already been made. "The Occident is corrupt now, and all that is powerful can, like Antaeus, renew its strength by touching the earth there".

Preparing for his departure, the artist collected the necessary materials – photographs of monuments of oriental art, reproductions, books, magazines and guidebooks.

Nava nava fenua (Delicious Earth)

1893-1894 woodcut for Noa Noa, 35.4 x 20.5 cm Art Institute, Chicago

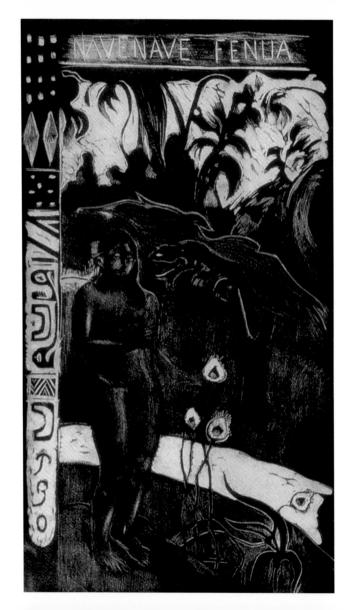

A new motif appeared in his works: a naked woman with the facial features of his mother, among tropical vegetation. Such was his *Exotic Eve* (private collection, Paris), an antipode of the two versions of the sorrowful *Breton Eve* (private collection, New York; Marion Koegler McNay Art Institute, San Antonio) painted only a year earlier. That exotic Eve was a link between his former style of the Martinique period and his future Tahitian one.

Te faruru (Making Love)

1893-1894 woodcut for Noa Noa, 35.6 x 20.3 cm Art Institute, Chicago

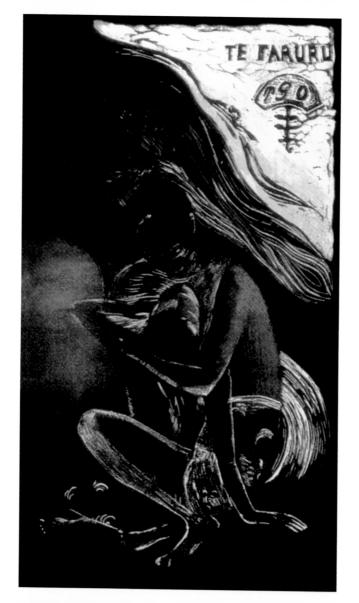

Having discussed his possible destination with his friends and rejecting the idea of going to Tonking or Madagascar, Gauguin finally decided on Tahiti. An attempt to get an appointment as a governmental official that would provide him with a living proved hopeless, and in order to raise money for his voyage and settlement, in February 1891 Gauguin announced a sale of his works. After that he paid a short visit to his family in Copenhagen.

Mahana no varua ino (The Day of the Bad Spirit)

1893-1894 woodcut for Noa Noa, 20.2 x 35.6 cm Art Institute, Chicago

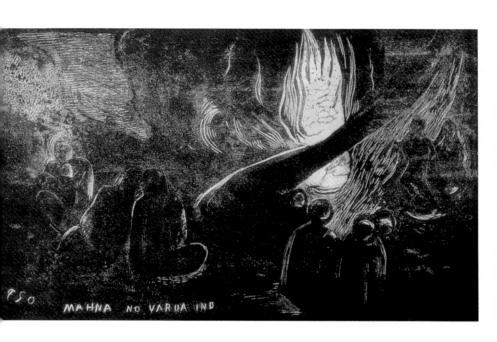

He was beginning to believe in his future fame, financial independence and, as a natural consequence, reunion with his family. At last, after a banquet in his honour given by his friends the Symbolists, Gauguin left for Tahiti in April 1891. He went alone, for none of his friends who had originally intended to go with him, ventured the voyage.

Manao Tupapau (Watched by the Spirits of the Dead)

1893-1894 woodcut for Noa Noa, 20.3 x 35.6 cm Art Institute, Chicago

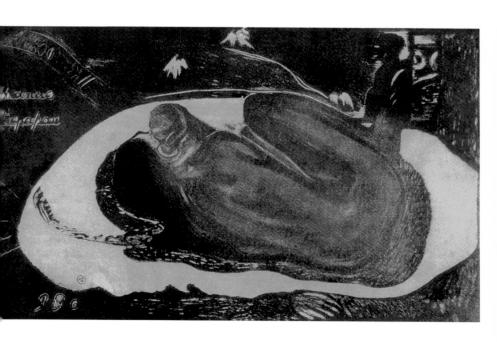

But Gauguin was not discouraged by the prospect of solitude. Strange as it may seem, he possessed two mutually exclusive qualities – a sober mind and incredible naivety. Leaving Europe he had visions of the harmonious and happy life of the Polynesians among whom he would find peace of mind and an opportunity to work to his heart's content.

Self-Portrait with a Palette

c.1894 oil on canvas, 92 x 73 cm private collection

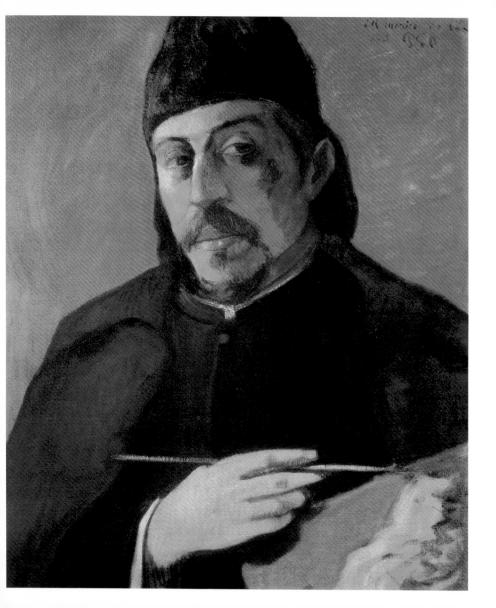

The European world with its bourgeois conventions, which had given birth to an insipid, uninventive art, and which blocked the way for anything that was alive, was too narrow for his romantic dream. "The terrible thirst for the unknown makes me commit follies", he confessed when he had just returned from Arles "[I] hope that you will see an almost new Gauguin: I say 'almost' because I don't claim to invent something entirely new.

The Cellist (Portrait of Upaupa Schneklud)

1894 oil on canvas, 92.5 x 73.5 cm Museum of Art, Baltimore

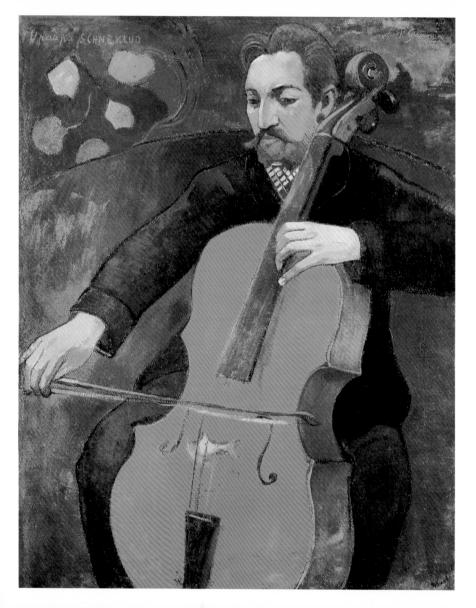

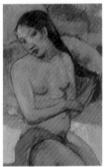

I only wish to discover in me an as yet unknown facet " – these prophetic words were written by Gauguin two years before his voyage to Tahiti, when he could not yet know that his wish would come true there. In the early morning of 8 June 1891, after sixty-three days at sea in forced idleness and feverish anticipation of a meeting with his future, Gauguin set foot on the soil of Noa Noa.

Mahana no Atua (Day of the God)

1894 oil on canvas, 68.3 x 91.5 cm Art Institute, Chicago

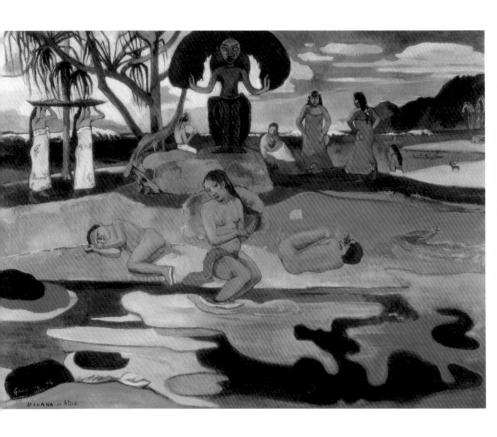

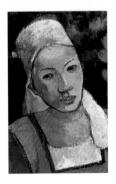

The day before he had celebrated his forty-third birthday. His first contact with Tahitian reality showed that Papeete was by no means paradise, that civilization – in the form of officials, traders and soldiers – had long since firmly established itself in this colonial capital of the island. He realized that the childhood of mankind, the idyllic past in which man was an integral part of nature, in quest of which he had left Europe, had to be sought outside the city here, too.

Breton Peasant Women

1894 oil on canvas, 66 x 92.5 cm Musée d'Orsay, Paris

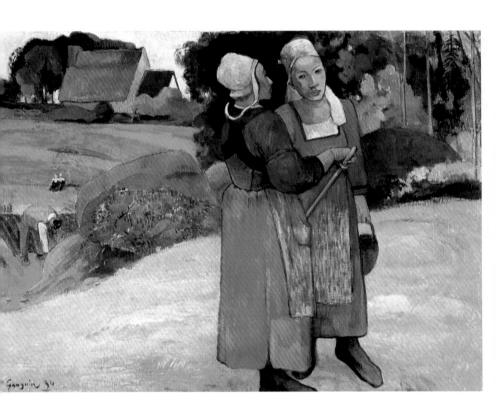

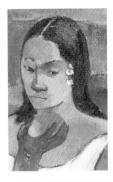

Nothing in Papeete, nor any of his fellow-passengers on the voyage inspired him to a picture. He hastened away from the capital and settled on the southern coast of Tahiti, in Mataiea, in one of the houses between the sea and a hill with a deep cleft overgrown by mango trees.

Nave nave moe (Sweet Dreams) or Sacred Spring

> 1894 oil on canvas, 73 x 98 cm The Hermitage, St. Petersburg

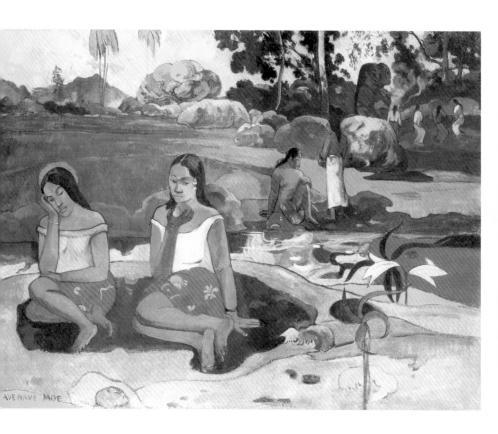

Enchanted with the bright colours of the sea and of the coral reefs, surrendering himself to the slow rhythm of Tahitian life, the artist imbibed and accumulated his new visual experiences. He drew a series of studies from nature, sketched characteristic poses, faces and groups of figures. One of the first portraits painted in Tahiti was *Woman with a Flower* (Ny Carlsberg Glyptotek, Copenhagen).

The Holy Night

1894 oil on canvas, 72 x 83 cm private collection

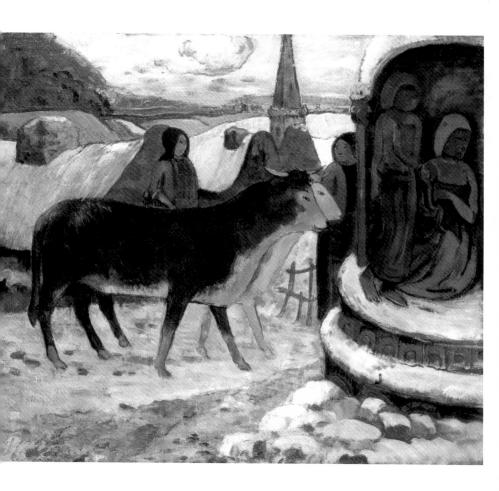

Although both the artist and the model seem to have felt a certain constraint, the portrait is remarkable for its monumental simplicity. The arrangement of the figure on the surface, the subtle modelling of the head and face, and the colouring all bespeak the artist's integral perception of the model and her character.

The Mill in Pont-Aven

1894 oil on canvas, 73 x 92 cm Musée d'Orsay, Paris

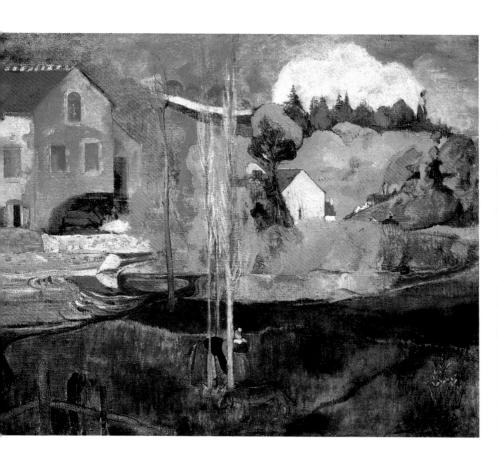

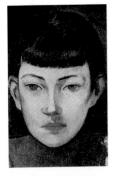

Oceanian nature almost at once enriched Gauguin's palette and called new plastic forms into being, although it was only eleven months after his arrival to Tahiti that he ventured to say that he had acquired a feel of Tahitian soil and its fragrance. In Mataiea, Gauguin also painted his first Tahitian land-scapes, to which belongs At the Foot of a Mountain (Hermitage, St. Petersburg), where the tiny figure of a horseman emphasizes the magnificence of nature.

Portrait of Jeanne Goupil

1896 oil on canvas, 75 x 65 cm Ordrupgaardsamlingen, Copenhagen

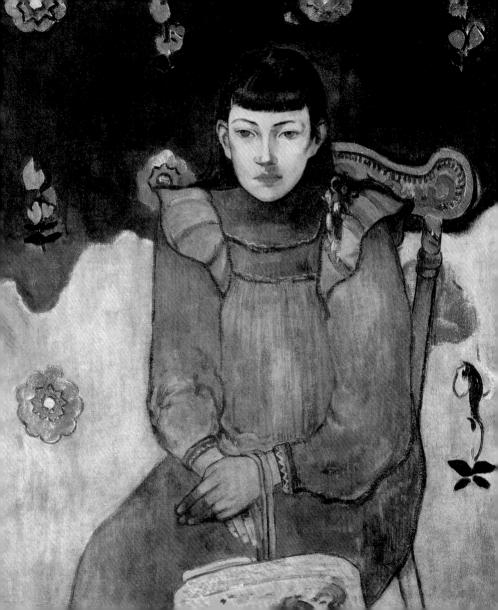

In a number of pictures of this period, the stylized effects of the cloisonnist technique are almost completely ousted by a softer and more natural treatment. The gently applied strokes of red paint against a large monochrome area of yellow in the foreground create the illusion of shadows gliding in the air and on the ground's surface.

Teapot and Fruits

1896 oil on canvas, 48 x 66 cm Museum of Art, Philadelphia

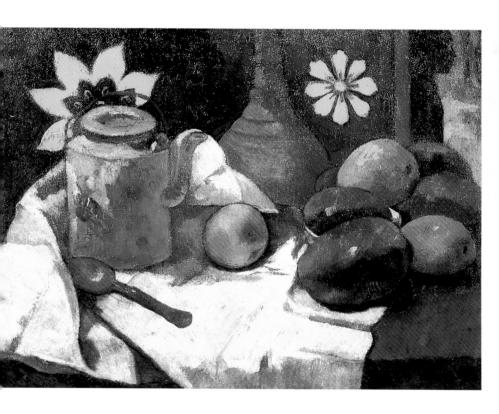

The same broad, sweeping brushwork distinguishes another landscape, *The Big Tree* (Art Institute of Chicago). While discovering the beauty of the new land, the artist did not feel it necessary to modify his visual impressions, since both the landscape and the people in it were fairly exotic, mysterious and picturesque.

Scene from Tahitian Life

1896 oil on canvas, 89 x 124 cm The Hermitage, St. Petersburg

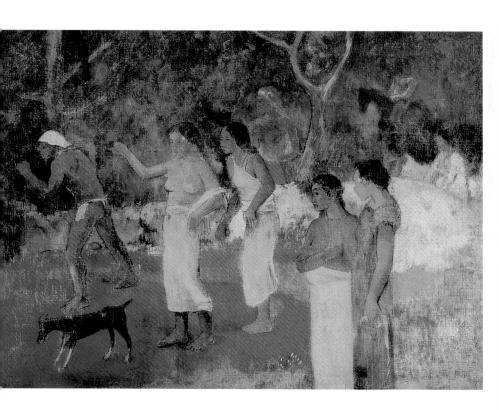

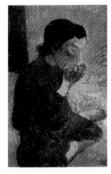

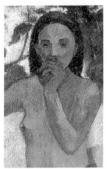

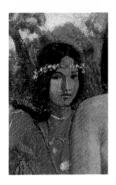

That is why his early Tahitian works display a greater verisimilitude. This idea – the opposition of civilization and barbarism – which goes back to the European Romanticist tradition, acquired a special significance in Gauguin's art.

It formed the basis of his aesthetic conception and inspired his interest in the culture of primitive peoples long before his arrival in Oceania.

Nave nave mahana (Delicious Day)

1896 oil on canvas, 95 x 130 cm Fine Arts Museum, Lyon

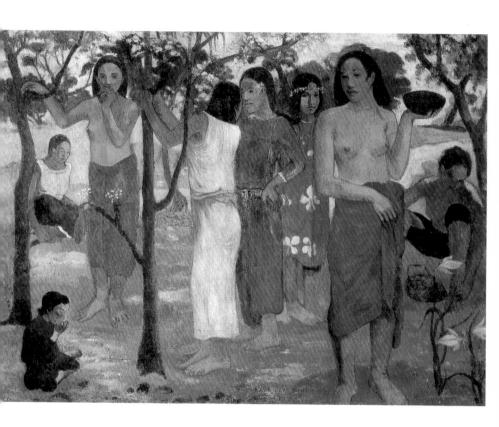

This idea also underlies his book *Noa Noa* and directly relates to one of the episodes narrated in it.

From now on the artist could orchestrate his planes and surfaces with the boldest lines and arabesques. He could "lay on the canvas red, blue... all this gold, all this sunny joyfulness without a second thought..."

Te arii Vahine (The King's Wife)

1896 oil on canvas, 97 x 130 cm Pushkin Museum of Fine Arts, Moscow

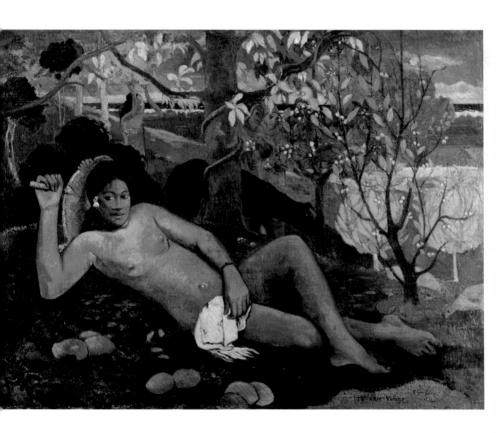

In Tahiti, Gauguin was reconsidering his attitude to Greek art, opposing it to archaic art, which, in his view, possessed greater value, as it emerged from the people's creative imagination. "The animal substance that remains in all of us," Gauguin wrote from Oceania, "is not at all deserving of scorn as is usually supposed. It was those devilish Greeks who thought up Antaeus, gathering his strength from touching the earth. The earth – that is our animal substance".

Te tamari no atua (Nativity)

1896 oil on canvas, 96 x 128 cm Neue Pinakothek, Munich

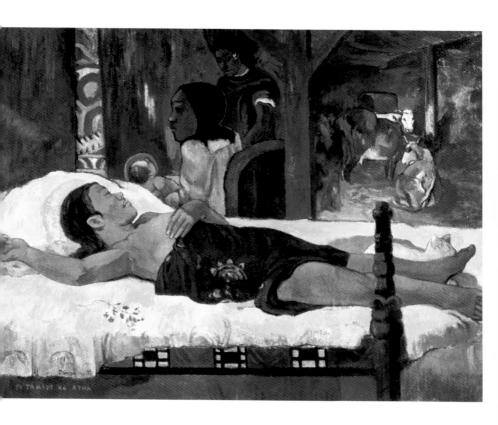

Most compositions are centred on one or two figures sitting, standing or lying down, with no narrative link between them. A case in point is – What! Are You Jealous? (Pushkin Museum, Moscow). Gauguin considered it (in August 1892) his most successful nude study.

Bé bé (The Nativity)

1896 oil on canvas, 66 x 75 cm The Hermitage, St. Petersburg

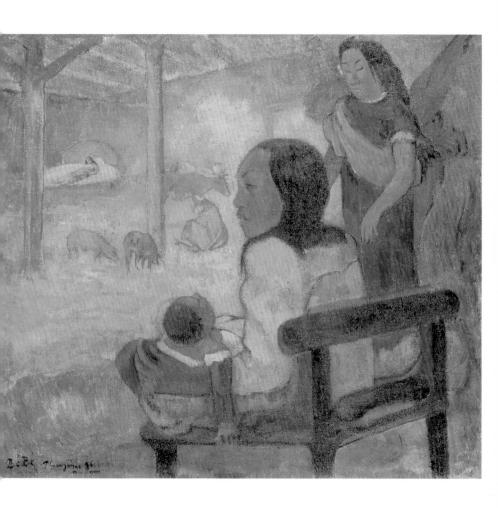

Sending it to the Copenhagen exhibition, he ranked it next in importance to his *Spirit of the Dead Watching* (Albright-Knox Art Gallery, Buffalo, New York; A. Conger Goodyear collection, 1965), which was particularly dear to his heart as a memento of Tehura, his Tahitian vahine.

Te vaa (The Canoe) or A Tahitian Family

1896 oil on canvas, 96 x 130,5 cm The Hermitage, St. Petersburg

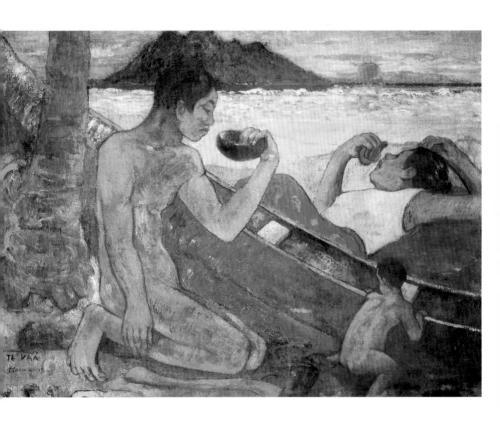

The first thing that struck Gauguin in Tahiti was the statue-like immobility of the natives, who could sit or stand in one and the same position for hours on end. This ability of his models greatly appealed to the artist, for lack of movement in his pictures had long become a more or less consistent principle since the Pont-Aven period.

Buddha

1898-1899 woodcut from the series "Vollard" 29.5 x 22.2 cm Art Institute, Chicago

The new orientation of Gauguin's creative research is evident in his *Tahitian Pastoral Scene* (Hermitage, St. Petersburg), *Amusements* (Musée d'Orsay, Paris) and *Autrefois* (private collection, New York). These works are not mere studies of Tahitian nature, but pictorial representations of the essence extracted from it and transformed by the artist's imagination. In the *Pastorales*, everything stands still, suggesting the enchanted world of reverie.

Eiaha ohipa (Tahitians in a Room)

1896 oil on canvas, 65 x 75 cm Pushkin Museum of Fine Arts, Moscow

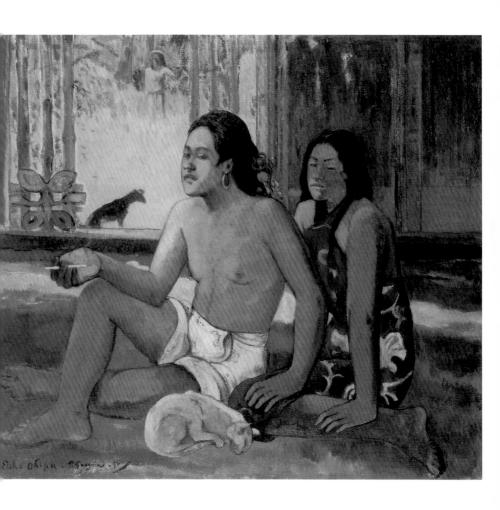

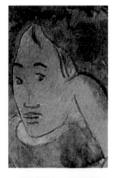

Paintings inspired by Polynesian legends occupy a special place in Gauguin's works. The lore and rituals of the Maori, already forgotten by Gauguin's contemporaries but recorded by Jacques-Antoine Moerenhout in an ethnographical study, which fell into the artist's hands, nourished his imagination and enabled him to "rekindle a fire out of the ashes of the old furnace".

Noa Noa, Sitting Tahitian

1896-1897 watercolour and ink, 19.5 x 17 cm Musée du Louvre, Paris

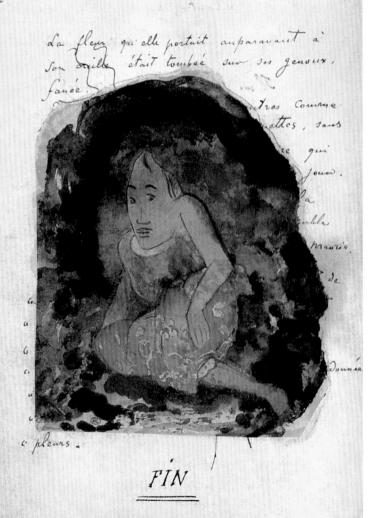

Fruitful though this stay in Tahiti was, illness and constant lack of money eventually forced Gauguin to return to France, where he was as ever haunted by the image of his "promised land".

In Paris he wrote *Noa Noa*, prepared drawings and prints for the text, and continued to paint on Tahitian motifs.

Noa Noa

c. 1897 woodcut, photograph and watercolour Musée du Louvre, Paris

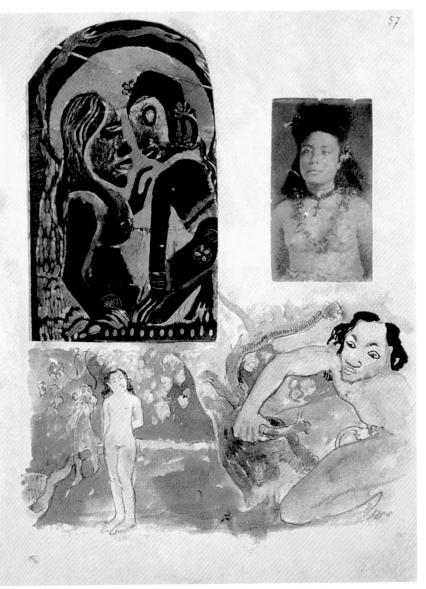

His Paris canvases seem to be woven from memories of his recent past, as, for example, Sacred Spring (Hermitage, St. Petersburg) and The Day of the God (Art Institute of Chicago). In France Gauguin was hounded by misfortune.

Vaïrumati

1897 oil on canvas, 73 x 94 cm Musée d'Orsay, Paris

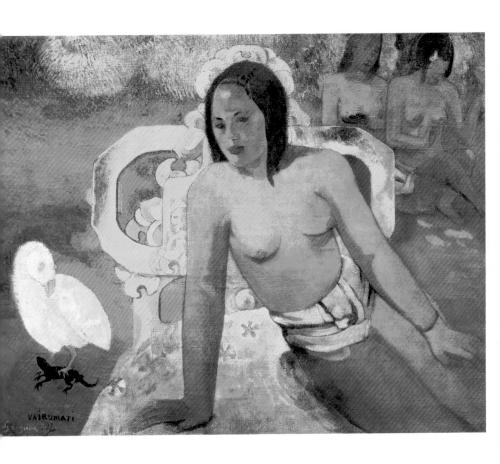

His efforts to re-establish relations with his family came to nothing, while a trip to Brittany ended in tragedy: he broke his ankle and sustained a wound, which never healed. But worst of all was the fact that the public and the critics did not accept his art. And soon, in the autumn of 1895, he again arrived in Tahiti.

Bathers

1897 oil on canvas, 60.4 x 93.4 cm National Gallery of Art, Washington

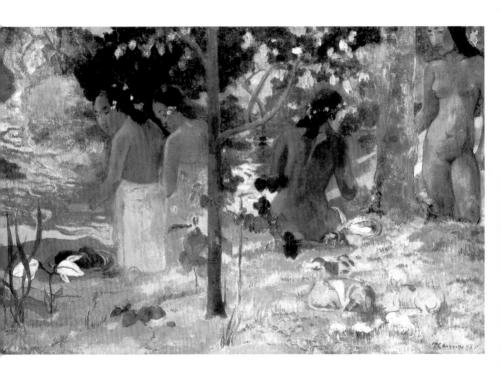

This time he settled on the west coast, at Punaauia, a small village near Papeete – the only place with a hospital and professional doctors, whose help Gauguin now needed almost daily. He built himself a bamboo cottage, and soon his new Tahitian vahine came to live with him. Very quickly he was again in desperate need of money. The futility and humiliation of his constant struggle for existence and the lost faith in his recognition as an artist made him think of committing suicide.

Te rerio (The Dream)

1897 oil on canvas, 95 x 132 cm Courtauld Institute Galleries, London

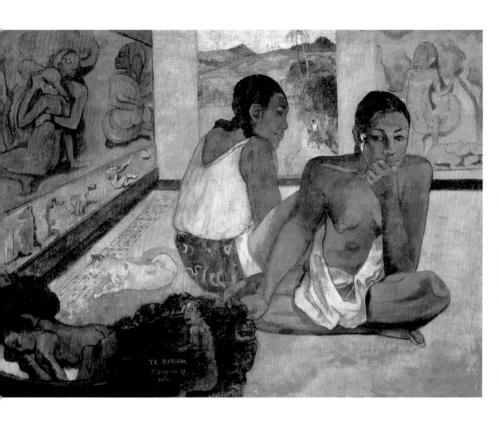

But the vital force of his creative impulse was still very strong, and his desperate pessimism soon gave way to a new urge to work. His unfading admiration for the visual, sensual beauty of nature distracted him from his pains and troubles, and in the spring of 1896, when he was passing through a period of profound depression, he painted a series of brilliant works which opened his second Tahitian period. The highlight of this group of paintings is *The Queen* (Pushkin Museum, Moscow).

Man Picking Fruits

1897 oil on canvas, 92 x 72 cm The Hermitage, St. Petersburg

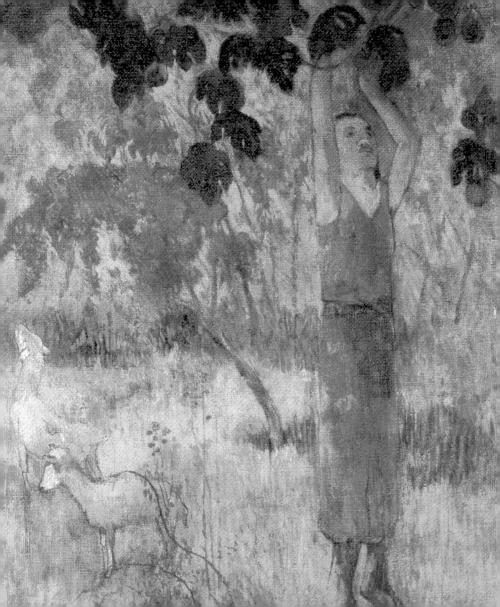

The Queen was the most perfect manifestation of his quest for primordial harmony. The artist repeated this composition with slight alterations and in different techniques several times – in a pen drawing, with watercolours and in woodcuts. Explaining his interpretation of this theme, which recurs in numerous works executed in Tahiti, Gauguin wrote that he wanted to evoke through his picture of simple, naked nature the feeling of a pristine, barbaric luxury.

Tarari maruru (Landscape with Two Goats)

1897 oil on canvas, 92 x 73 cm The Hermitage, St. Petersburg

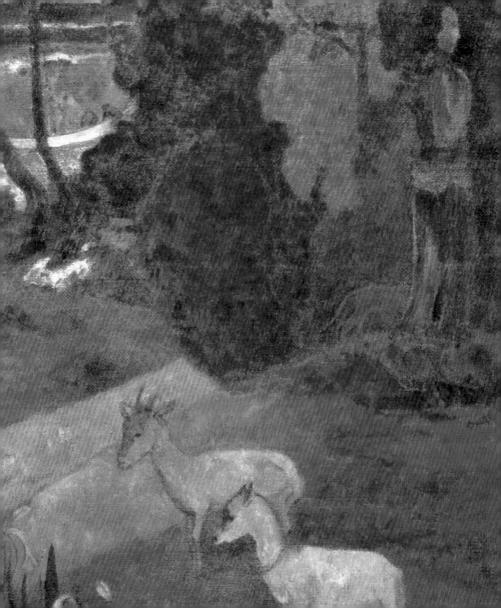

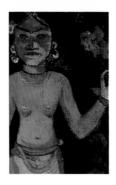

Gauguin's canvases of that period are peopled with static figures of Tahitian women absorbed in dreamy contemplation; they are depicted in isolation, in pairs or groups, in front of their huts or inside them. So are *The Dream* (Courtauld Institute Galleries, London), *Tahitians in a Room* (Pushkin Museum, Moscow), *The Canoe* (Hermitage, St. Petersburg) and its version *The Poor Fisherman* (São Paulo Museu de Arte), *Why Are You Angry?* (Art Institute of Chicago) and *Nevermore* (Courtauld Institute Galleries, London).

Where Do We Come From? What Are We? Where Are We Going?

1897-1898 oil on canvas, 139.1 x 374.6 cm Museum of Fine Arts, Boston

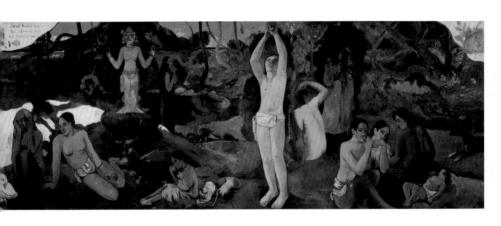

Living in the South Pacific, Gauguin perceived oriental art not as a European admiring exotic curiosities, or as those artists who brought back from their travels wrestling scenes and various piquant subjects, or like Pierre Loti, a famous writer who looked down at Tahiti or Japan with an air of condescending superiority.

Human Miseries

1898-1899 woodcut from the series "Vollard" 19.4 x 29.5 cm Art Institute, Chicago

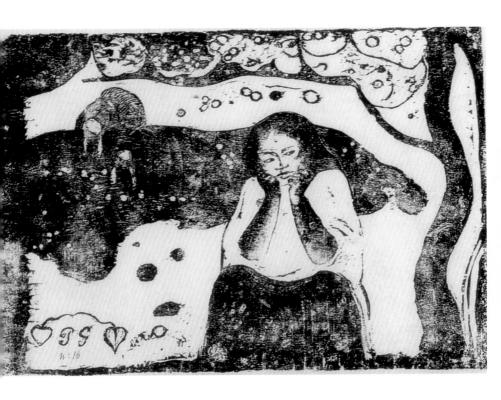

For Gauguin, the art of the Orient was an integral part of his own aesthetic conception. His keen observation enabled him to discern essential similarities in various primitive cultures – Greece and Polynesia, Ancient Egypt and Japan, India and Cambodia, Italian primitive and medieval French artisans.

Rave te hiti aamu (The Idol)

1898 oil on canvas, 73 x 91 cm The Hermitage, St. Petersburg

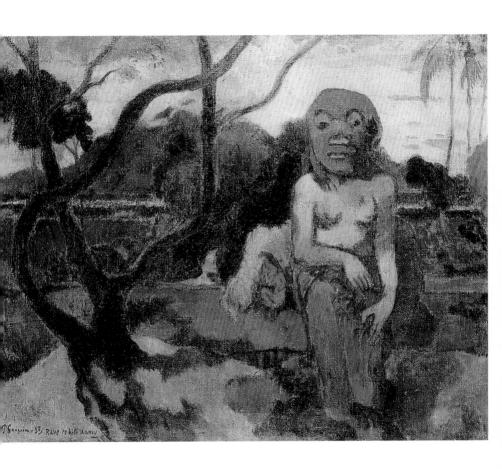

The life in Polynesia, where the natural world itself was full of mystic symbolism, and where the very existence of man – from birth to death – had a simpler, purer and more natural meaning, led to a further development of symbolist tendencies in Gauguin's art. 1897 is one of the unhappiest years in Gauguin's life.

Faa iheihe (Preparations for a Feast)

1898 oil on canvas, 54 x 169 cm Tate Gallery, London

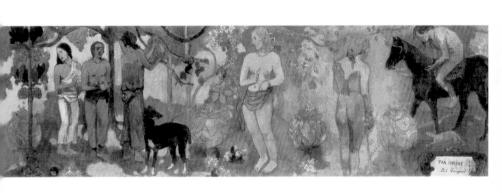

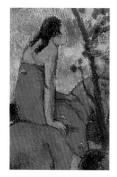

He received news of the death of his sixteen-year-old daughter, suffered unbearable physical pain and was subject to spells of blindness. Driven by all this to the point of committing suicide, he created his largest picture, Where Do We Come From? What Are We? Where Are We Going? (Museum of Fine Arts, Boston, USA), painted as his final statement.

Te Tiai na Oe Ite Rata (Are You Waiting for a Letter?)

oil on canvas, 73 x 94 cm private collection

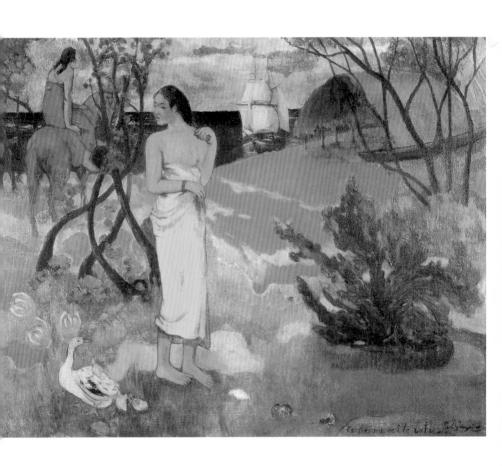

Two of the Hermitage works are related to this composition: Landscape with Two Goats, executed in a dark, sombre tonality, and Man Picking Fruit from a Tree, painted in a thin misty layer of ghostly yellow.

The artist's return to life was marked by such works as *Preparations for a Feast* (Faa Iheihe) (Tate Gallery, London), *Gathering Fruit* (Pushkin Museum, Moscow), *Two Tahitian Women* (Metropolitan Museum of Art, New York), *Maternity*, *Woman Carrying Flowers* and *Three Tahitian Women against a Yellow Background*.

Two Tahitian Women

1899 oil on canvas, 94 x 72.2 cm Metropolitan Museum of Art, New York

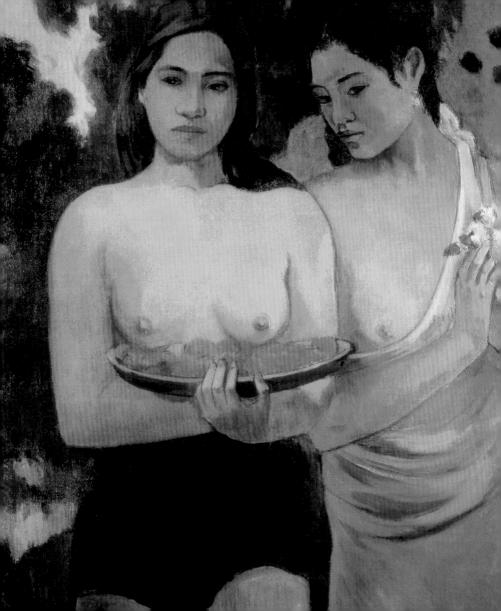

Some of them are thematically or iconographically related to *Preparations for a Feast*, in which Gauguin returns to the motif of the Promised Land, using the specific set of pictorial devices.

A decorative pattern also appears in the Hermitage version of *Maternity*, but its function here is markedly different. The motif of a woman suckling her baby turns into a symbol of motherhood, of the great mystery of nature.

Women on the Seashore (Maternity)

1899 oil on canvas (relined), 94 x 72 cm The Hermitage, St. Petersburg

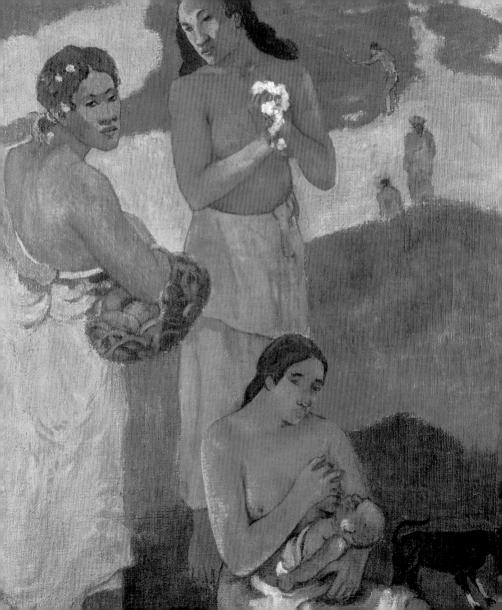

During this period Gauguin elaborated yet another theme, which had long preoccupied him – the theme of the common origin of different religions, particularly Buddhism and Christianity, to which he devoted a number of socio-theological writings and paintings, among them *The Last Supper* (Mme Katia Granoff collection, Paris) and *The Great Buddha* (Pushkin Museum, Moscow).

Ruperupe (Gathering Fruit)

1899 oil on canvas, 128 x 190 cm Pushkin Museum of Fine Arts, Moscow

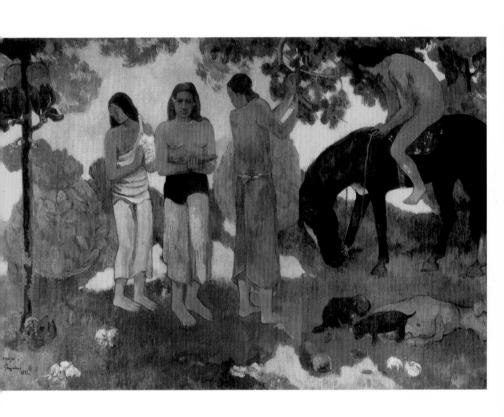

A burst of creative energy inspired Gauguin to undertake the last journey of his life, yet further into the heart of Polynesia, to the tiny island of Hivaoa in the Marquesas group. "Here poetry appears of its own accord, and when you paint you only have to abandon yourself to reverie to give expression to it. I only ask for two years of health, and not too many money worries, which now have an excessive

The Great Buddha

1899 oil on canvas, 134 x 95 cm Pushkin Museum of Fine Arts, Moscow

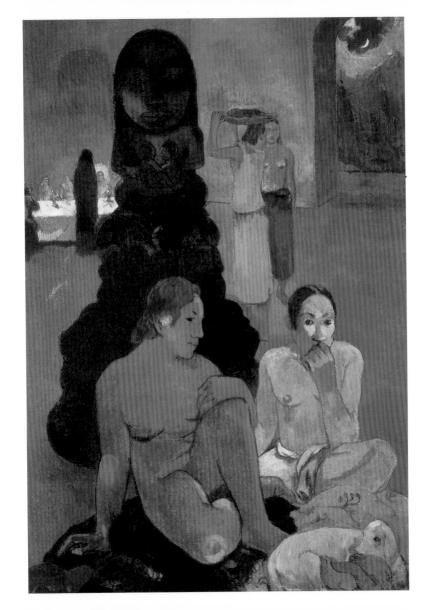

hold on my nervous temperament, in order to reach a certain maturity in my art. I feel that I'm right about art – but will I have the strength to express it convincingly enough", he wrote from his newly built "Maison du Jouir" in Atuona.

Fascinated by the wild, primitive beauty of nature, the artist pours out onto his works a joy that is almost painful in its intensity.

Three Tahitian Women against a Yellow Background

oil on canvas (relined), 68 x 74 cm The Herrmitage, St. Petersburg

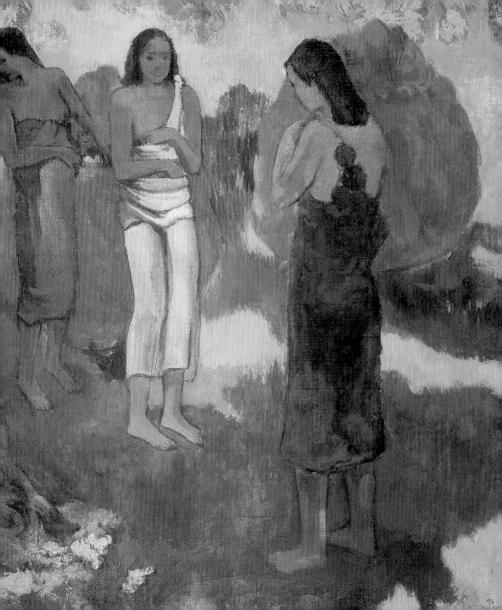

It is hard to believe, that such joyous paintings, as *Still Life with Parrots, The Ford* (both in the Pushkin Museum, Moscow), the two versions of *Riders on the Beach* (Folkwang Museum, Essen; Stavros Niarchos collection, New York), and *Girl with a Fan* (Folkwang Museum, Essen), were done by a fatally ill man almost on the threshold of his death.

Te avae no Maria (The Month of Mary) or Woman Carrying Flowers

1889 oil on canvas, 97 x 72 cm The Hermitage, St. Petersburg

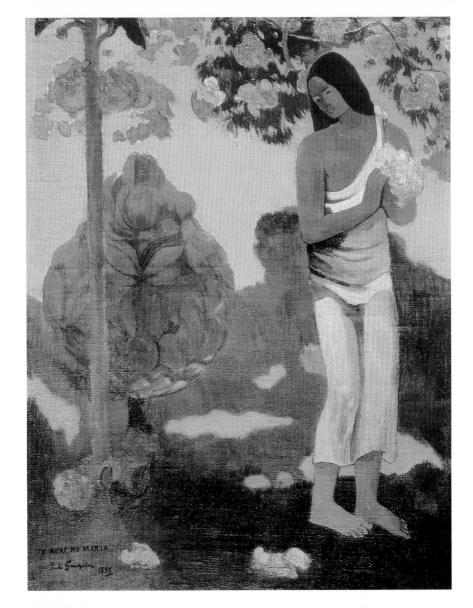

Fate gave Gauguin two years of life in Atuona, and despite his illness and his exasperating conflict with the colonial authorities, he still had enough strength to prove that "in his art he was right". His immersion in the depths of a different culture outside the European tradition gave his work a specific character, which partly hid the true significance of his artistic aspirations in exotic, savage forms.

Horse on the Road

1899 oil on canvas, 94 x 73 cm Pushkin Museum of Fine Arts, Moscow

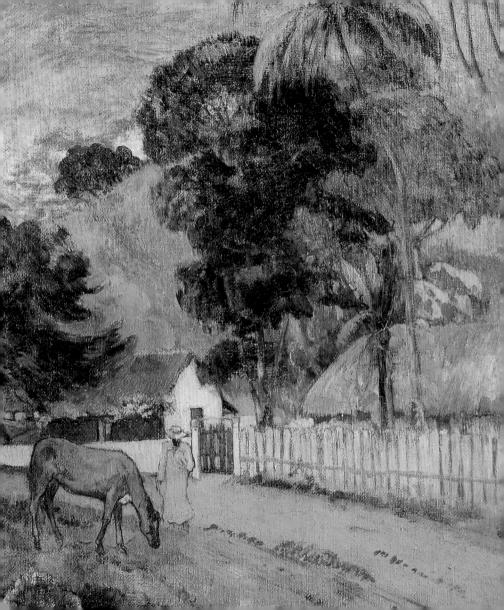

Turning to the art of primitive and ancient peoples, to their folklore and crafts, Gauguin not only rescued from oblivion the poetic world of Oceanian culture and made its luxurious forms and colours accessible to us, but also enriched the artistic tradition of the West.

Still Life with Grapefruits

c.1901 oil on canvas, 66 x 76 cm private collection

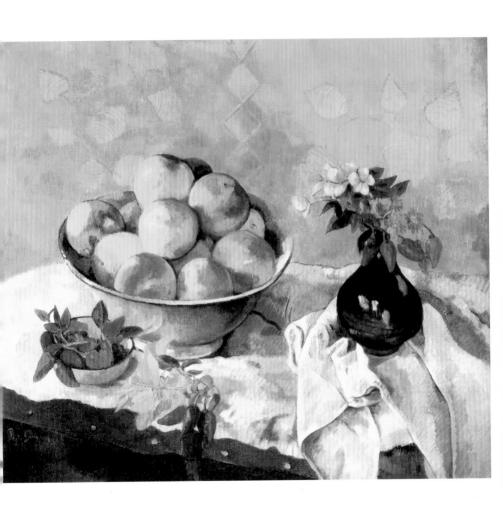

Gauguin belongs to those masters whose work marks a turning point in the history of art. In his quest of creating, and by no means imitating, the real world, he discovered its intrinsic fantastic elements and set new goals before art. After Gauguin, interest in black art or the art of the Aztecs, Ancient Egypt or Japan became a matter of course.

Sunflowers

1901 oil on canvas, 72 x 91 cm The Hermitage, St. Petersburg

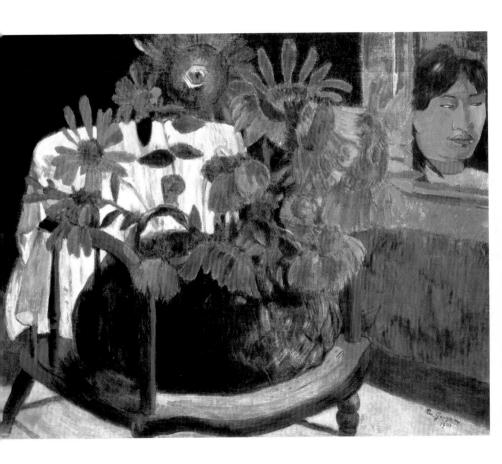

But Gauguin never imitated other artists' art forms or the work of his contemporaries. He borrowed and absorbed only that which was in time with his own artistic and philosophic vision, and which he embodied in his work in a new original manner. His borrowings made local art part of world culture.

The Ford (The Flight)

1901 oil on canvas, 76 x 95 cm Pushkin Museum of Fine Arts, Moscow

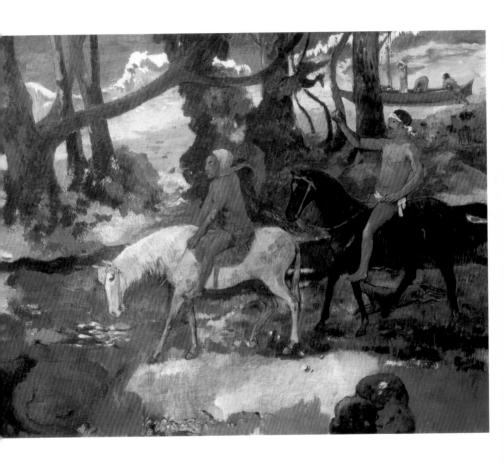

The aspiration to record emotional and mental states not through the subject-matter, but with the help of plastic forms and colouring, led Gauguin beyond the boundaries of the classical artistic tradition, which was considered the only correct and acceptable one in Europe.

Rider

1901-1902 monotype in black and grey on vellum paper 50 x 44 cm Musée des Arts Africains et Océaniens, Paris

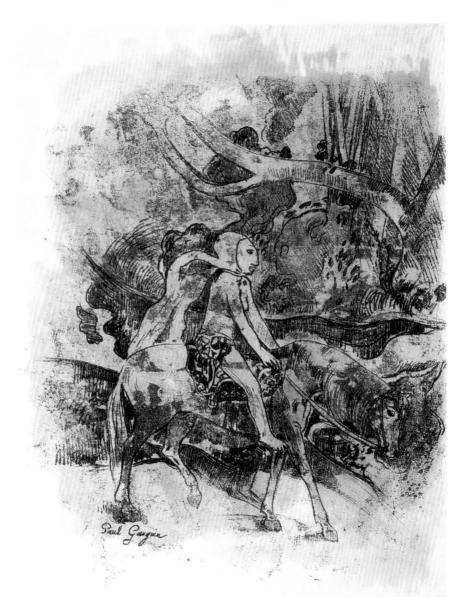

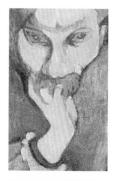

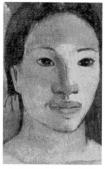

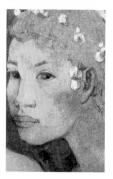

The simplification of form, the use of pure colour, the approach to colour as a pictorial equivalent of light, the arrangement of space by the juxtaposition of contrasting areas of colour, the right to construct a work according to his own independent artistic laws, the right to intervene actively in the visible world and by reshaping it to reveal some as yet unknown aspects of reality – in short, everything that lay at the source of modern art, if it did not find its systematic realization in Gauguin's works, was at least formulated by him on the level of artistic theory.

Barbaric Tales

1902 oil on canvas, 131.5 x 90.5 cm Folkwang Museum, Essen

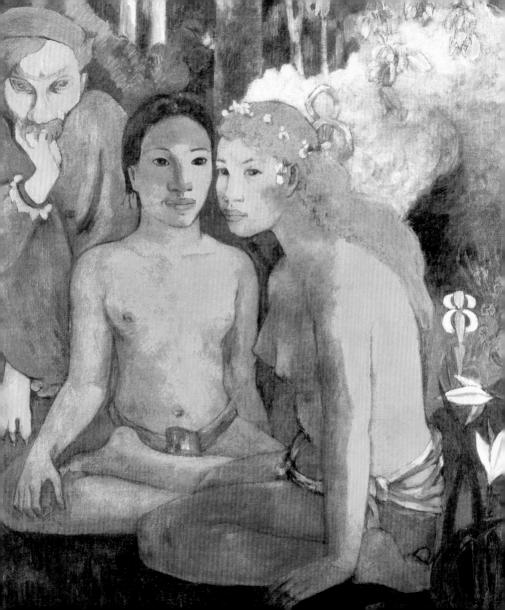

His clear understanding of the creative tasks which the next generations were to resolve, enables us to regard Gauguin as one of the immediate predecessors of twentieth-century art. His last entry in his memoirs reads: "You see, I believe that we all are workers... Before all of us is the anvil and the hammer, and our duty is to forge". Ever since he first picked it up, Gauguin's "hammer", remained in his hand until his dying day.

Woman with a Fan

1902 oil on canvas, 92 x 73 cm Folkwang Museum, Essen

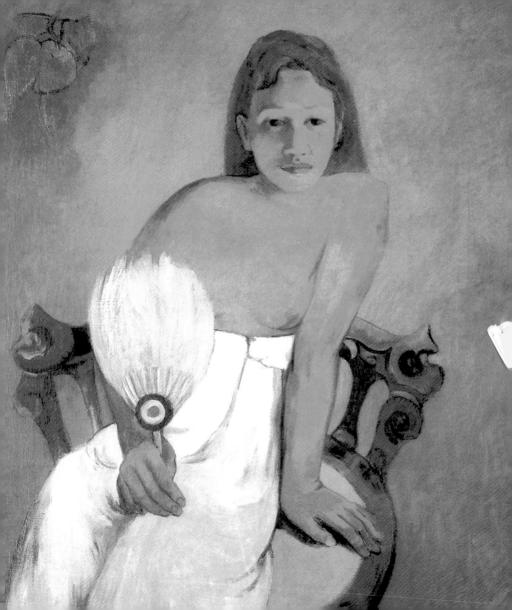

Flower Vase by the Window	11	
Ford (The) (The Flight)	241	
Four Breton Girls (The)	33	
G		
Garden at Vaugirard	9	
Great Buddha (The)	229	
Н		
Head of a Tahitian Woman	99	
Hello, Mr Gauguin	73	
Hina tefatou (The Moon and the Earth)	143	
Holy Night (The)	175	
Horse on the Road	235	
Human Miseries	215	
Human Miseries (Grape Harvest in Arles)	57	
1		
Ice Skaters in the Frederiksberg Park	17	
In the Hay (A Hot Summer Day)	51	

La Orana Maria (Ave Maria)	109
Les Parau Parau (Conversation)	103
Look Mysterious	87
М	
Mahana no Atua (Day of the God)	169
Mahana no varua ino (The Day of the Bad Spirit)	161
Man Picking Fruits	209
Man with an Axe	95
Manao Tupapau (The Soul of the Dead Ones is Awake)	135
Manao Tupapau (Watched by the Spirits of the Dead)	163
Maruru (Satisfied)	155
Matamoe (Landscape with Peacocks)	129
Merabi metua no Tehama (Teha'amana Has Many Parents)	147
Mill in Pont-Aven (The)	177
N	
Nafea faa ipoipo? (When Will You Marry?)	133
Nava nava fenua (Delicious Earth)	157
Nave nave mahana (Delicious Day)	185

Nave nave moe (Sweet Dreams) or Sacred Spring	173
Nirvana (Portrait of Meyer de Haan)	91
Noa Noa	201
Noa Noa, Sitting Tahitian	199
0	
Old Women in Arles (In the Arles Hospital Garden)	49
Otahi (Alone)	139
P	
Parau Na Te Varua Ino (Evil's Words)	117
Path in Papeete (A Tahitian Street)	107
Portrait of Jeanne Goupil	179
Portrait of Meyer de Haan	81
R	
Rave te hiti aamu (The Idol)	217
Rest (The)	113
Rider	243
Ruperupe (Gathering Fruit)	227

Scene from Tahitian Life	183
Schuffenecker Family (The)	71
Seated Breton	35
Self-Portrait	89
Self-Portrait "Les Misérables"	59
Self-Portrait "To My Friend Carrière"	27
Self-Portrait in front of Easel	25
Self-Portrait near Golgotha	29
Self-Portrait with a Hat	151
Self-Portrait with a Palette	165
Self-Portrait with the Yellow Christ	83
Sleeping Child	15
Snow Effects (Snow in Rue Carcel)	13
Still Life with Fruits	55
Still Life with Grapefruits	237
Sunflowers	239

T1:: 0 : 10	
Tahitian Pastoral Scene	145
Ta matete (The Market)	125
Tarari maruru (Landscape with Two Goats)	211
Te Alua (The God)	153
Te arii Vahine (The King's Wife)	187
Te avae no Maria (The Month of Mary) or Woman Carrying Flowers	233
Te faruru (Making Love)	159
Te raau rahi (The Big Tree)	105
Te rerio (The Dream)	207
Te tamari no atua (Nativity)	189
Te Tiai na Oe Ite Rata (Are You Waiting for a Letter?)	221
Te tiare farani (Flowers of France)	101
Te vaa (The Canoe) or A Thahitian Family	193
Teapot and Fruits	181
Three Tahitian Women against a Yellow Background	231
Two Tahitian Women	223

V	
Vahine no te tiare (Woman with a Flower)	93
Vaïraumati tei oa (Her Name is Vaïraumati)	123
Vairumati	203
Van Gogh Painting Sunflowers	63
Vision after the Sermon (The) (Jacob Fighting with the Angel)	39
W	
Wave (The)	47
Where Do We Come From? What Are We? Where Are We Going?	213
Woman with a Fan	247
Women on the Seashore (Maternity)	225
Wrack Collectors	69
Υ	
Yellow Christ (The)	67
Young Breton Bathers	65
Young Breton Seated	37
Young Bretons at Bath	31

Young Tahitian Man (Young Man with a Flower)